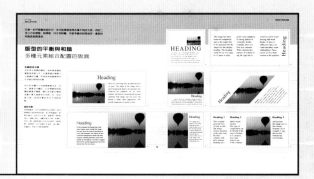

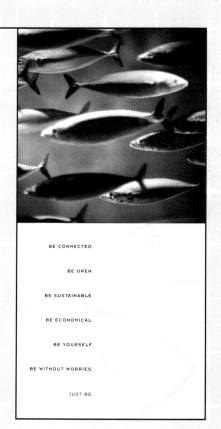

BE CONNECTED.

BE OPEN.

BE SUSTAINABLE.

BE ECONOMICAL.

BE YOURSELF.

BE WITHOUT WORRIES.

JUST BE.

# 設計與編排

## 圖文編排之

## 基本原理與設計應用

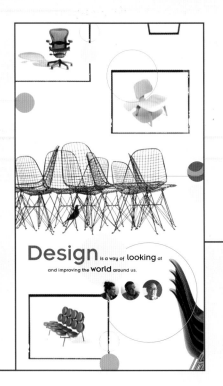

**Design** is a way of **looking** at
and improving the **world** around us.

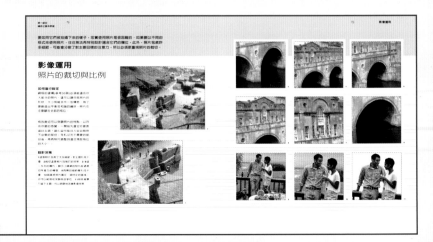

**影像運用**
照片的裁切與比例

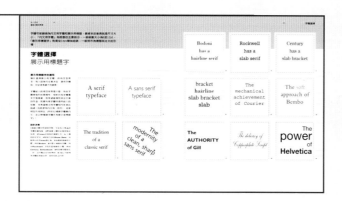

# 設計與編排

## 圖文編排之
## 基本原理與設計應用

David Dabner 著

普保羅 譯 · 張晴雯 校審

視傳文化事業有限公司

# 設計與編排
## —圖文編排之基本原理與設計應用
## Desing and Layout:
## Understanding and Using Graphics

著 作 人：DAVID DABNER

翻　　譯：普保羅

校　　審：張晴雯

發 行 人：顏義勇

編 輯 人：曾大福

版面構成：陳聆智

封面構成：鄭貴恆

出 版 者：視傳文化事業有限公司

　　　　　永和市永平路12巷3號1樓

電話：(02)29246861 (代表號)

傳真：(02)29219671

印刷：香港利豐雅高印刷貿易有限公司

郵政劃撥：17919163視傳文化事業有限公司

**每冊新台幣：500元**

行政院新聞局局版臺業字第6068號

ISBN 986-7652-00-2

2003年9月1日　初版一刷

**A QUARTO BOOK**

First published in North America in 2003
by HOW Design Books
an imprint of F&W Publications, Inc.,
4700 East Galbraith Road
Cincinnati, OH 45236

Copyright © 2003 Quarto Inc.

ISBN 1-58180-435-0

Library of Congress Catalog Card Number
available upon request

Conceived, designed, and produced by
Quarto Publishing plc

The Old Brewery
6 Blundell Street
London N7 9BH

QUAR.UUDL

**Project editor** Vicky Weber
**Art editor** Karla Jennings
**Assistant art director** Penny Cobb
**Designer** James Lawrence
**Copy editor** Sarah Hoggett
**Proofreader** Gillian Kemp
**Indexer** Diana Le Core

**Art director** Moira Clinch
**Publisher** Piers Spence

**Manufactured by**
Universal Graphics Pte Ltd., Singapore
**Printed by**
Leefung-Asco Printers Ltd, China

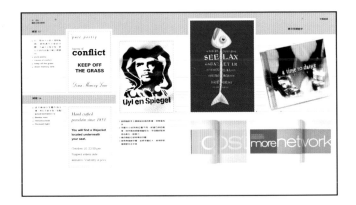

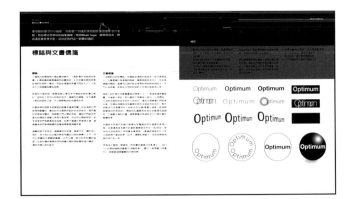

# Contents

# 導引

這本書係針對初學者和設計老手,概述圖文編排設計的過程。在此書中,初學者可學到如何做出有效的編排設計,對設計老手而言,亦可從中得到全新的學習課程或創新點子。

這本書分為兩個部份,第一部份是編排之基本原理的解釋,內容包含編排設計的基本元素—字體、色彩、構成、插圖和照片等的運用方法。第二部份為編排設計之實例與應用,著重在設計的專門表現媒介,像標準字、雜誌、小冊子、廣告和網頁設計,及其個別須顧慮到的部分。以上兩個部份中,每個主題都含有專業性的實例簡述與習作,讓你有親自嘗試的機會。

這本書鼓勵使用者分析及評估自己的作品,這樣可將你培養成一位設計師,並且把設計規劃中的問題點出。客觀地分析你所做的每個步驟是一項必要的學習。

此外，你還要欣然接受批評並視其為理所當然。如果你獨自工作，缺乏他人的建議，你可能會陷入僵化的危機，無論如何，為了追求真正的進步，所有對設計的指正都應該要直述，像「我不喜歡這樣」的評語對問題的改進毫無建設性，最後只會阻礙你的發展。

為了能善用這本書，先確定你具備使用電腦的能力，有助於演練書中所有習題，並且，你還需要先準備好一套適用於編排的基本軟體配備。

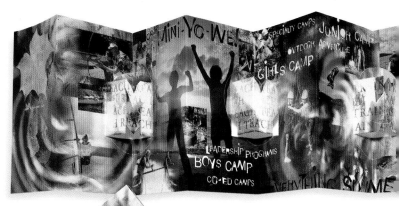

# 如何使用這本書

## 第一部份

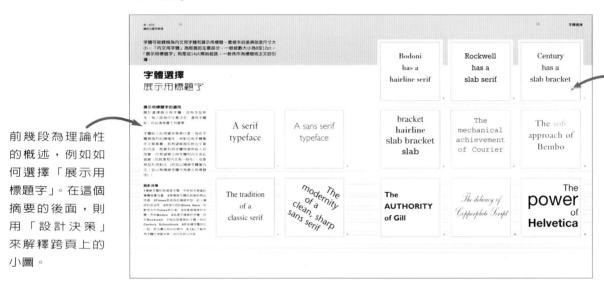

前幾段為理論性的概述，例如如何選擇「展示用標題字」。在這個摘要的後面，則用「設計決策」來解釋跨頁上的小圖。

這些列舉的作品清楚地闡明了設計理論。每一則設計都加以編號並與設計決策中的釋文相對應。

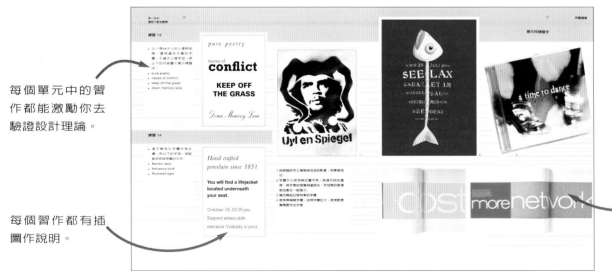

每個單元中的習作都能激勵你去驗證設計理論。

每個習作都有插圖作說明。

專業的設計範例用以鼓舞你的精神。參考世界各地的專業設計師如何達到製作上的要點。

## 第二部份

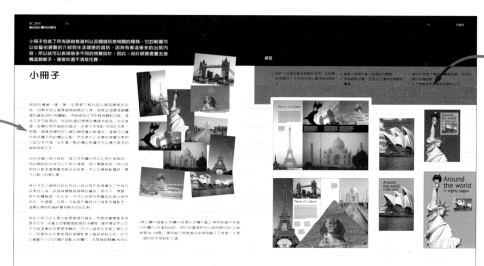

每個單元的導引，都包含了常見的技巧，並指導你達到專業設計的方法。

在這個開放的練習空間中，透過提供的指引發揮你的設計創意。你可從範例中獲取些許靈感，但如何創新設計則是一項挑戰。完成後，別忘了尋求朋友的意見，建設性的建議可讓你進步神速。

在下方的專業示範中，教你將物件分解並審視個別要素，對了解設計師構成畫面的過程有很大的幫助。

來自世界各地的範例，包含一系列專業設計師的設計手法。

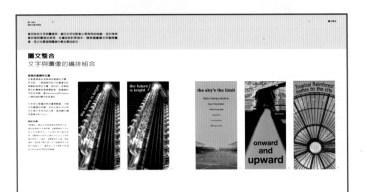

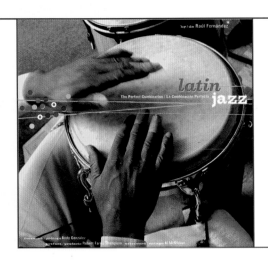

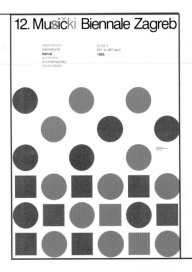

# 第一部份

## 編排之基本原理

這個部份解釋並圖示出設計過程中的各種要素－或稱為基本構成的「建構區塊」。例如,影像的運用、選擇字體和圖文整合。只要你願意花時間,練習並探索每個部份的細節,編排設計將與你更親近。

每個設計步驟都伴隨著圖示與扼要的說明,以及練習題的操作,專業設計師的作品則展示他們如何透過討論製作完稿。藉由這些範例,可以實際看到設計決策的過程。

要如同它們被拍攝下來的樣子,忠實使用照片是很困難的,如果要以不同的格式來使用照片,往往無法再特別設計適合它們的擺位,此外,照片包含許多細節,可能會分散了對主要目標的注意力,所以必須重視照片的裁切。

## 影像運用
### 照片的裁切與比例

**如何進行設定**

網格的建構(參考30頁)必須能適合你大部分的照片,通可以讓你就照片的形狀、大小和給合作一些種思,為了要劃造出平衡及和諧的編排,照片往往需顧及全部的格位。

格放裁切可以突顯照片的特點,以得告你要的感覺,一開始先選定好要表達的手法,讓引圖可能太大但且動拆不必要的部份,等裁切完不需要的都但者,再將照片調整到適合擺設格位的大小。

**設計決策**

1選擇照片包含了太多細節,對主題形成干擾 2裁切這張照片加強它的效果 3-8透一系列的圖片,顯示「簡單的與不相適裁切所產生的轉變 9簡單的線條畫來形成干擾 10具有吸照片圍在一個特定的區塊,你可以輕易地突顯其從事件 11框除畫面只留下主題,可以明顯的改善影像效果

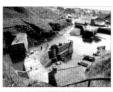

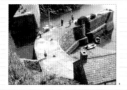

規範版面形狀和尺寸大小是編排設計時的要點，恰當的長寬比例，會增加設計空間的舒適感，並創獨具一格的文體形式。

# 基本版型
## 版面的成形與構成格式

**包含要素：**

設計案的版型，由預想的結果和設計功能來決定。

選擇印刷用的版型設計時，紙張的形狀大小和印壓的靈活性都可列入參考，並找出工作時的變數和目標，如果客戶需要指定編排形式，則較難有機會出現設計奇想。

經濟因素也影響著版面格式，通常特殊剪裁在生產時耗費較高，同樣地，多餘紙張裁切後所造成的浪費，也會導致成本提升。

當你和愈多不同的代理商合作，你該開始思考設計中的美感問題，不要因某個形狀造成訊息表示不清，也不要留下過多的空白。

如果主要是使用相片或插圖，就該先以圖片的內容做參考，文字則簡單地圍繞圖像，如果只是處理文字，則要使用文體專屬的格式－以小說為例，當閱讀字塊中的一行字多於10到12個字，目光很容易快速進入疲勞狀態。此外，要確定外形不干擾閱讀。

當你將注意力轉移到設計元素的個別形狀時，應該更邏輯地去思考你想要達到的目標，設計中所有的造形與感覺都來自形狀，例如一本青年雜誌中，就該要有許多有趣的形狀，並且足以讓畫面顯得熱鬧。而一個設計老手，就應當擅於讓簡而小的形狀，在空間中無限擴張。

**設計決策**

1一張廣告海報的尺寸必須符合佈告欄的大小。2一份正式文件不需引人注意的設計，而要重視內容。3包裝盒的格式要符合商品需求。4街頭上發放的宣傳單，可以用醒目的造形令人加深印象。5格式上的訊息文字，是給人的第一印象。6超市的宣傳手冊不僅要大小合於顧客的購物袋，本身還要包含大量的資訊，所以摺疊式的設計較為理想，但是要注意到摺線是否會破壞你所設計的物件。7圖片的形狀以主題內容決定，而文章則繞於圖片四周。8瘦長形的影像適合垂直的格式。

1

**2**

Re: Basic Design Principles by David Dabner

**3**

**4**

**5**

Building for Success

The Sky is the Limit

**6**

**7**

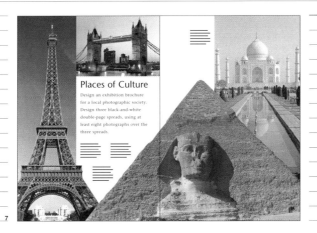

Places of Culture

Design an exhibition brochure for a local photographic society. Design three black-and-white double-page spreads, using at least eight photographs over the three spreads.

**8**

Around the world in eighty pages

練習 1

- 找一張有趣且畫面豐富的相片。
- 掃描至電腦中並選用適合這個主旨大小的格式。
- 接著用同樣的相片,將它切割成可供選擇的格式。
- 最後裁下影像中某些精采的部分。評論你所看到的現象。

練習 2

- 找一首詩、食譜或一份導覽。
- 擇一在 A5 上做排版,並用 11pt大小的字型。
- 加入其他的特徵闡明文章。
- 現在用不同的格式和形狀做實驗。
- 印出作品並加以評析。

基本版型

**ILENE PERLMAN**
PHOTOGRAPHER

1. 此肖像格式提供這張分割影像最佳的空間。
2. 在這張攝影師的宣傳卡片中，風景照格式可包含兩張寬圖和一張窄圖。

---

## CHERRY PIE

Makes 1 pie

**Ingredients**
2 cups all-purpose flour
1 cup shortening
1/2 cup cold water
1 pinch salt
2 cups pitted sour cherries
1 1/4 cups white sugar
10 teaspoons cornstarch
1 tablespoon butter
1/4 teaspoon almond extract

**Directions**

1　Cut the shortening into the flour and salt with the whisking blades of a stand mixer until the crumbs are pea sized. Mix in cold war. Refrigerate until chilled through. Roll out dough for a two crust pie. Line a 9 inch pie pan with pastry.

2　Place the cherries, sugar, and cornstarch in a medium size non-aluminum saucepan. Allow the mixture to stand for 10 minutes, or until the cherries are moistened with the sugar. Bring to a boil over medium heat, stirring constantly. Lower the heat; simmer for 1 minute, or until the juices thicken and become translucent. Remove pan from heat, and stir in butter and almond extract. Pour the filling into the pie shell. Cover with top crust.

3　Bake in a preheated 375° F (190° C) oven for 45 to 55 minutes, or until the crust is golden brown.

---

## CHERRY PIE

Makes 1 pie

### Directions

1　Cut the shortening into the flour and salt with the whisking blades of a stand mixer until the crumbs are pea sized. Mix in cold war. Refrigerate until chilled through. Roll out dough for a two crust pie. Line a 9 inch pie pan with pastry.

2　Place the cherries, sugar, and cornstarch in a medium size non-aluminum saucepan. Allow the mixture to stand for 10 minutes, or until the cherries are moistened with the sugar. Bring to a boil over medium heat, stirring constantly. Lower the heat; simmer for 1 minute, or until the juices thicken and become translucent. Remove pan from heat, and stir in butter and almond extract. Pour the filling into the pie shell. Cover with top crust.

3　Bake in a preheated 375° F (190° C) oven for 45 to 55 minutes, or until the crust is golden brown.

**Ingredients**
2 cups all-purpose flour
1 cup shortening
1/2 cup cold water
1 pinch salt
2 cups pitted sour cherries
1 1/4 cups white sugar
10 teaspoons cornstarch
1 tablespoon butter
1/4 teaspoon almond extract

## 練習 3

- 在一張紙上畫上10到15個形狀，並剪下。每個形狀可任意轉動或增減。
- 試著用色紙、亮米紙、報紙、雜誌，小塊的纖維等不同的媒材剪出形狀。
- 將他們裱貼在大卡片上，依受歡迎程度排列，在形狀四周簡短寫下美感價值。

## 練習 4

- 看看以下列出的字和圖形，無論是由電腦或手工，形狀會使你和圖中的文字有所聯想：例如刺的、柔軟的、強壯、虛弱、醜陋、無聊、規律、興奮、世俗的、流動、複雜、精緻的。
- 當你完成以上的練習，找另一組反意字和其形象。
- 最後將兩種練習互作參照。第一組可能較令你滿意，而第二組似乎會較不一致，且並非相當正確。

1

2

3

4

1.風景照的格式,讓有趣的文章和影像有很多發揮的機會,為了避免使設計中的任何部分排版超出紙張摺頁,構成時必須善用各種文章長度和圖片大小。這樣的結果在視覺上是令人興奮的,也是最清楚且貼近好設計的編排。

2.被切割的圖片和有造形的內文在設計中產生一種戲劇性。

3.伴著撕紙的封閉臉部特寫產生一股有力且令人心悸的畫面。

4.這張郵票上有任意排列的珠寶。這種趣味化的手法,促使單張郵票有更具創意的運用。

所有良好的編排設計都應在其不同元素中展現一種平衡感，這種令人感到和諧的平衡，能使讀者的視覺被編排設計物所吸引，並且理解編排設計中所要傳達的意義。

# 基本版型
## 版面中單字或標題的放置

**盡可能地利用空間**

在編排設計中，為講求平衡與和諧，所有的元素都要經過精確的排列，在此一首要練習中，我們將可看到一個單字如何以各種型態出現在版面上，藉此了解字與空間的變化所產生的不同氣氛。

字型的編排方式有很多：可以靠左(也就是對齊左線)，靠右或置中。也可以改變字的水平或垂直方向，或置於一角，甚至打破以往的形式，不再和頁緣平行。

**設計決策**

**1**字型置中並略高於中線，會產生平和感。**2**字型向頂邊靠近，但不完全貼近。**3**字型觸及頂邊，也別有一番風味，但仍需靠其他元素來維持版面的平衡。**4**置於頁底。**5**將字型拉長與版面同寬。**6**放大。**7**縮小。**8**將字型貼近頁緣以增加畫面張力。**9**在方向上作變化。**10**以不同角度呈現字型，在閱讀上或許有些困難，卻是一種視覺上的對比。**11**字型變成圓弧形，並置於中上。**12**置於下方。**13**字型順著波浪狀起伏。最後介紹的三種排法看起來比較生動。

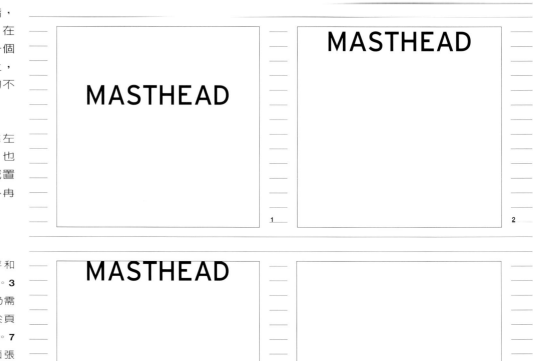

MASTHEAD

5

MAST
HEAD

6

MASTHEAD

7

MASTHEAD

8

MASTHEAD

9

MASTHEAD

10

MASTHEAD

11

MASTHEAD

12

MASTHEAD

13

**練習 5**

- 挑選一張風景相片A6大小的版面。
- 以字首大寫的文字形式，將至少7個字母的字適當地排放在工作區上。
- 字型置中。
- 分別作出三種不同的設計：置左；垂直排列；45度角排列。
- 試著將字繞成圓弧形。
- 增加字間的距離。
- 觀察以上變化，並決定他們給人的感覺。

Marketing

Marketing

Marketing

Marketing

Marketing

Marketing

**練習 6**

- 挑選A4大小的版面。
- 置入至少7個字母的文字，並將文字反白。
- 在反白的情況下，使用無襯線字體較易辨識。
- 嘗試不同字體大小與字間距離。
- 將版面底色分為黑白各半，將字放在其中一邊的中央。
- 當你完成四種變化組合後，試析它們的效果，再根據你的分析修訂作品。

Legible

LEGIBLE

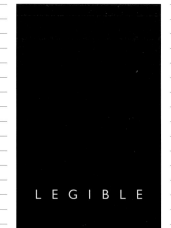

Legible

LEGIBLE

LEGIBLE

LEGIBLE

版面中單字或標題的放置

1

2

1 將標題與相關內容置中，
　以補足符號的對稱造形。

2 將標題置右貼近頁緣，具
　有一種未來感。

3 這種富想像力的水平與垂
　直對比排列，適合精確且
　具科技性的建築組織。

4 將標題分割為二的方式，
　可增加視覺上的趣味，卻
　不失其可辨識度。

4

3

在組合標題與圖像或一段文字時，標題不僅要配合版面需求，也要和
其他元素達成和諧，才能順利得到所要的效果。

# 基本版型
## 版面中標題與圖像或段落文章的組合

### 用各種編排元素以產生和諧

有更多的元素存在，你的選擇也就更
多：藉由各種不同編排元素的大小、
角度和方向變化，使它們能在版面上
相互平衡。

最好讓視覺區塊的大小比例不同，不
是標題大於圖片以支配著圖，就是小
於圖片，使圖片比文字引人目光。重
點是你要想清楚標題與圖像，哪一個
才是編排中最主要的元素。

### 設計決策

標題和內文的字體可相同，但字級大小或
筆劃粗細要有差異。**1**對稱的形式。**2**不對
稱的形式。**3**選擇性地給予不同程度的強
調，圖片的內容會影響選擇的走向，這個
例子是由標題所主導。**4**由圖片主導。**5**圖
文比例不同最富戲劇效果。**6**圖文組合在
視覺上非常有意思。**7**標題和內文的走向
不同，可增加編排的多樣性。**8**文字的排
列可與圖片的造形相呼應。

## Typefaces

The ever-increasing flexibility of computer typesetting equipment
with the ability to set a wide range of point sizes has done much to
popularise the trend towards the use of typeface families. These are
typefaces available in a range of weights and derivatives. Many new
typefaces now have a semi-bold version that offers the designer a
useful choice of weight between the regular and bold designs.

1

## Typeface availability

The ever-increasing flexibility
of computer typesetting
equipment with the ability to
set a wide range of point
sizes has done much to

popularise the trend towards
the use of typeface families.
These are typefaces available
in a range of weights and
derivatives. Many new

typefaces now have a semi-
bold version that offers the
designer a useful choice of
weight between the regular
and bold designs.

2

# TYPEFACES

## Typefaces

The ever-increasing flexibility of computer typesetting equipment with the ability to set a wide range of point sizes has done much to popularise the trend towards the use of typeface families. These are typefaces available in a range of weights and derivatives. Many new typefaces now have a semi-bold version that offers the designer a useful choice of weight between the regular and bold designs.

3

6

# Typefaces

## Typefaces

The ever-increasing flexibility of computer typesetting equipment with the ability to set a wide range of point sizes has done much to popularise the trend towards the use of typeface families. These are typefaces available in a range of weights and derivatives. Many new typefaces now have a semi-bold version that offers the designer a useful choice of weight between the regular and bold designs.

4

7

## Typefaces

The ever-increasing flexibility of computer typesetting equipment with the ability to set a wide range of point sizes has done much to popularise the trend towards the use of typeface families.

## Typefaces

The ever-increasing flexibility of computer typesetting equipment with the ability to set a wide range of point sizes has done much to popularise the trend towards the use of typeface families.

5

8

- 從報紙或雜誌上剪下一篇有標題，且內文至少50-70字的短文。用A5的相紙版面和有襯線字體，將標題置於文章正上方。
- 將標題改為無襯線粗體字，內文齊左，讓編排能夠跳脫固定中心的形式。
- 嘗試標題大小的不同，和其與內文的空間關係，可將標題插入文章內，或是和內文產生衝突，不要畏懼任何新方法。

# Lee Konitz

Associated with 'The birth of the cool', Lee Konitz came from Chicago and has been playing alto sax for over five decades. He is now 75 and has made hundreds of albums, mainly with small record companies. What marks out his career is that he declined early on to be yet another Charlie Parker clone; he has remained an exploratory, innovative saxophonist.

# Lee Konitz

Associated with 'The birth of the cool', Lee Konitz came from Chicago and has been playing alto sax for over five decades. He is now 75 and has made hundreds of albums, mainly with small record companies. What marks out his career is that he declined early on to be yet another Charlie Parker clone; he has remained an exploratory, innovative saxophonist.

# Lee Konitz

Associated with 'The birth of the cool', Lee Konitz came from Chicago and has been playing alto sax for over five decades. He is now 75 and has made hundreds of albums, mainly with small record companies. What marks out his career is that he declined early on to be yet another Charlie Parker clone; he has remained an exploratory, innovative saxophonist.

## Lee Konitz

Associated with 'The birth of the cool', Lee Konitz came from Chicago and has been playing alto sax for over five decades. He is now 75 and has made hundreds of albums, mainly with small record companies. What marks out his career is that he declined early on to be yet another Charlie Parker clone; he has remained an exploratory, innovative saxophonist.

練習 8

- 找一張適合的圖片，並使用些許內文，圖片必須佔全面積的80%。
- 接著顛倒圖文比例，圖片占20%而文字和空白處占80%，並試著變化圖文的角度。
- 最後，由你自己分配圖文比例，再試作一次。
- 當你完成了這些練習，分析並評論它們個別的效果，再根據你個人獨到的見解，修正這些範例。

## 版面中標題與圖像或段落文章的組合

two magpies = 雙喜 double happiness (shuǎng xǐ)

**magpie :** The characters for 'magpie'; xǐ què, literally mean 'bird of happiness'. A picture of two magpies facing each other stands for 'double happiness', shuāng xǐ, symbolic of conjugal bliss. The call of a magpie foretells the arrival of a guest, good news, or good fortune. A magpie resting on a plum branch conveys the wish 'happiness before one's brow'; xǐ shàng méi shāo, as the word for 'plum' and 'brow'

are both pronounced méi. Magpies also served to preserve the integrity of a marriage, according to legend. When a husband and wife were to be apart for any reason, they would break a mirror and each take half. If the wife was unfaithful, her half of the mirror turned into a magpie that flew back and informed her husband. Consequently, an image of a magpie is often placed on the back of a mirror.

double happiness 喜 171

1

1 這個編排設計成功地整合兩
種非常不同的語言，讓兩種
語言既可被辨讀又不衝突。

2 標題所運用的顏色可以半透
明地覆蓋在內文上，創造出
另一種強烈的視覺衝擊。

Il y en a que j'aime plus que d'autres. Les gens ne les comprennent pas tous de la même façon : quand ils les découvrent, je les découvre. Je suis étonné et bouleversé quand, parfois, j'en emmène un au format gigantesque de l'affiche.
Leur petite taille, pratique et humble, impose une grande précision dans la narration, par le mot, ou l'image : une gymnastique que j'adore, celle du raccourci.
Il y a des "collectionneurs", des "petits coupons" qui ont existé et que j'ai supprimé par manque de place, vidéo, DRAMA... et j'ai réimprimé, avec des corrections.
Il y a des collectionneurs. Il y a eu des articles dans les journaux sur ces petites images.... notamment à Paris, à Londres, ou à New York.

**Petits formats cartonnés, j'aime le bruit qu'ils font**

Cette exposition s'appelle SUPER !
Le "SUPER !"-VERNISSAGE a eu lieu le 26 mai 00. L'exposition dure jusqu'au 29 septembre 00. Il sera peut-être remont(r)ée à Paris.
D'ordinaire données, les petites images seront vendues 1 F pièce pendant toute la durée de l'exposition, dans le "SUPER !"-MARCHÉ.

Cinq premiers "petits coupons" créés en 1994.
La "collection" en compte aujourd'hui, une centaine.
Cent prochains sont à l'état de notes, et je suis aujourd'hui certain d'avoir le profond désir d'en créer de nouveaux, toute ma vie durant.

2

The image, size and interesting cropping ensure that the image dominates the text, giving a dramatic feel to the composition.

**SATURN**

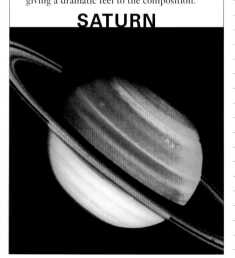

**Saturn**

Drastically reducing the image size and including more text gives the design a much more informative feel and encourages the reader to delve into the story and use the image as little more than a visual reference.

## Saturn

Here, the image size has been increased to occupy a third of the area, but the emphasis is still on the text. The image has been cropped and much of the detail has been lost. In situations where the information contained in the image is not of critical importance, this is a useful way of pulling the reader into the article.

在單一的平面編排設計中，你可能需要處理各種不同的元素，例如二至三行的標題、副標題、內文和附圖。所要考量的因素越多，畫面的和諧就越難達到。

# 版型的平衡與和諧
## 多種元素組合配置的版面

### 生動的多元素

決定各元素間的關係，和所要強調的重點是首要工作。先選擇適合標題大小粗細的字體，然後其他的副標與內文也施以相同的步驟。

內文的字體大小也需要審慎決定，另外，需要多少欄位？以及標題如何和欄位數產生關聯？圖片是否配合欄寬或會不會太擁擠或太空洞？在一切定案之前，必須先嘗試作出不同的搭配。

### 設計決策

1對稱編排：內文和標題的份量相當，而且標題置中的效果很和諧。2不對稱編排：重點在圖片，且內文少於第一個範例。3標題為主。4圖片為主。5雖然格式不同，但圖片仍是主題。6標題和內文的走向迥異。7將標題、副標題、內文和圖片作變形。8多欄位的編排，有較多空間強調標題。

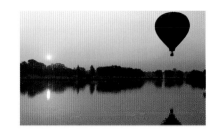

# Heading

Here, text and image take up equal amounts of space. The shape of the image allows more background detail to be included, thus reducing the emphasis on the main subject, the balloon. Justifying the text and centring both image and text gives the design a rather static appearance. The overall composition is gentle in feel.

1

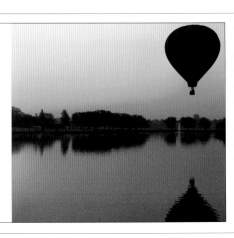

## Heading

In this example the image has much more impact, even though the image and text have the same proportions as in the first example. The reason for this is that the background detail has been reduced, drawing attention much more quickly to the balloon. The text is ranged left and the overall appearance has more drama than the one above.

2

# HEADING

This approach uses a strong display heading to catch the reader's eye before he or she moves on to the image and text. The size of the heading in bold capitals ensures that it dominates the design. The other elements in the arrangement have been reduced to the point where they become almost insignificant.

3

The image has been removed completely, and so the reader has to be attracted into the subject by the display heading. The heading could be set very large or, if space is tight, given extra emphasis by being placed in vertically. In this example, there are four text columns. With columns this narrow, it is better to range the type left to avoid excessive word spacing and word breaks. If there is sufficient copy, you could introduce some subheadings. These can be set in a bold version of the typeface.

Heading

6

## Heading

Here the image size is enlarged to occupy two-thirds of the format, giving a change of emphasis. This has a similar effect to that shown in the second example, in that the image is the main attraction and text is pushed into the background.

4

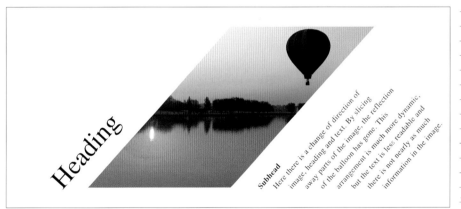

Heading

**Subhead** Here there is a change of direction of image, heading and text. By slicing away parts of the image, the reflection of the balloon has gone. This arrangement is much more dynamic, but the text is less readable and there is not nearly as much information in the image.

7

## Heading

The emphasis here remains on the image, although text and image occupy more or less the same amount of space. Cropping the image and concentrating upon the balloon quickly attracts the eye to the subject. This treatment means losing background detail.

5

## Heading 1

This example gives the best of both worlds. The image attracts attention; at the same time, the three columns with their separate headings give

## Heading 2

added visual interest. This type of composition can be flexible if the copy is limited; as a variation, you could remove one of the columns

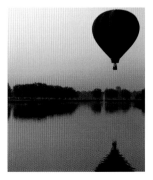

## Heading 3

and increase the image size or the column measure. As in example 7, range the text left without any word breaks.

8

**練習 9**

- 用練習 8 的格式與式樣，將內文與圖片分置兩旁，標題則置於兩者正上方。
- 加大圖片的面積成為主題，內文和標題置於同一邊。

# Equal Proportions

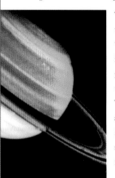

The image size and the text have equal emphasis. 'Bleeding off' the image into the left-hand edge gives the design added visual impact.

The problem here is that a lot of the image area has now been lost, and so its informational value is diminished.

# Larger Image

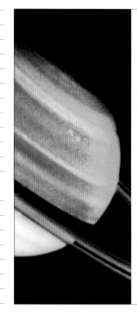

This arrangement has even more drama. The image size has been increased and now bleeds off on two sides. Again, the problem is the information that is lost as the image is decreased further: the rings of the planet have almost disappeared.

**練習 10**

- 利用練習 9 中的物件，將圖片改成瘦長型，並增加文章內容，標題則以不同角度呈現。
- 最後，將圖片切成圓形，文字順著圖片形狀排列。
- 當你完成了這些練習，分析並評論它們個別的效果，再根據你個人獨到的見解，修正這些範例。

### Abstraction is Nearer

Visually, this looks more interesting because the proportions of the two elements are unequal. An added visual trick is that the heading runs at an angle. By restricting the image to a small area, it becomes more abstract – but the amount of information in the image has been dramatically reduced.

# Circular Shapes

Although the image shape looks good, it has no informational value whatsoever and has become pure abstraction. This is acceptable if shape alone is the criteria for the design. The circular shape invites a text to be set around it, which gives a good structure to the composition. In this type of arrangement, the text should be ranged left; this avoids the kind of exaggerated word spaces that would be produced with justified setting.

## 多種元素組合配置的版面

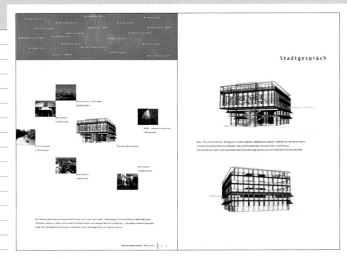

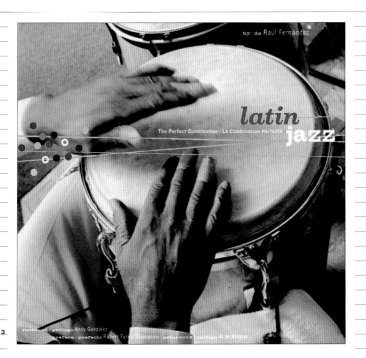

1 垂直的標題完美地與加大的背景圖片融合在一起。

2 影像和文字的底線對齊，這個範例是表現空間平衡慣用的手法：具現代感的設計。

3 在標題與副標題的位置通過兩條直線，和諧的律動與該張背景圖像的風格相符。

4 圖片和標題的隨意安排，產生一種緊密感，也增添了這種造形設計的視覺趣味。

5 使用圓形造形編排是較特殊的排法：順著圖片的圓弧邊緣排列的文字，有著引人注目的和諧感。

網格將版面分成許多個別的區塊單元，排列文字、圖片和標題時，這些小單元扮演著引導的作用。
網格扮演著「組織者」的角色，有助於將東西邏輯化地排列，也是設計師們合作一個案子時的必備工具。

# 版型的平衡與和諧
## 網格底線的運用

### 內容決定格數

網格的數量取決於使用物件的多寡，所包含的內容物越多，網格的用途便隨之增加。

一個簡單的網格，可分成縱切橫切各三格的等分割。

配合長度、重要性與面積相異的圖片，網格的分割會愈複雜並且有不同的大小。

### 設計決策

整體網格的四邊邊距會顯示出來，且格框與格框之間也會有間距。1此為簡易的九格網格,注意頂端（頭）、底部（尾）和邊緣留下的空白，當要組成一個網格時，用極細線作內部分割，並使用1pt粗的線條畫外圍線。2如同這個範例，訊息應從每個單元的左上方開始。3在分割網格時，必須將兩頁展開，以符合閱讀習慣。4一張圖片就佔滿一個框格。5圖片也可以跨格，例如以1×1,1×3,2×2,3×3的方式增加網格數。6更複雜的網格會有許多大小比例不同的單元。7狹窄的網格便可被作為配合圖片的文字欄位。

1　　2

3

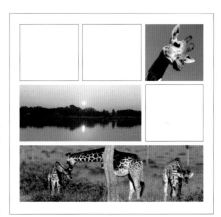

4

5

6

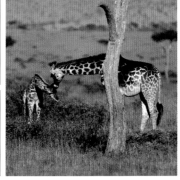

## 練習 11

- 用一張A5的風景照版面，將面積縱橫等分成三份，四邊邊距6釐米。
- 至少在五個框格中置入10pt級數的無襯線字體，加上標題，並確認內文是齊左放置。
- 在網格中嘗試各種排法。

## 練習 12

- 將版面換成A4大小的方格，並橫切成四等份，縱切五份，其中一個縱欄位的格寬必須是其它四格縱欄位寬的一半。
- 從雜誌中選一段文字，用9pt的字體級數大小、2pt行距，齊左配置，內文總字數以一個網格單位的容量為限。
- 現在選用三張圖片，用練習11中的標題，以圖片與文字的各種大小和網格數量，進行多種版型組合的試驗，當你要改變文字尺寸時，記得仍要保持網格單位的尺標範圍。

**Heading**

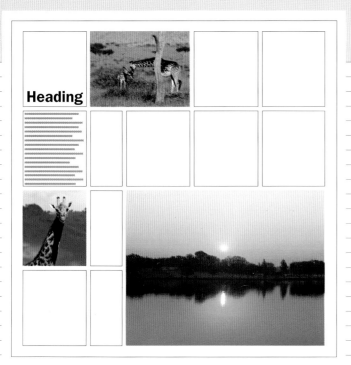

**Heading**

*inside* **HAVANA**

photographs by **Andrew Moore**

1

2

**Heading**

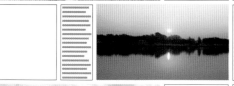

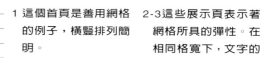

3

1 這個首頁是善用網格的例子，橫豎排列簡明。

2-3這些展示頁表示著網格所具的彈性。在相同格寬下，文字的配置可以有各種不同形式。使畫面具有忙碌而熱鬧的效果。

字體可被歸類為內文用字體和展示用標題，最根本的差異就是尺寸大小，「內文用字體」 為版面的主要部分， 一般級數大小為8至12pt，「展示用標題字」 則是從14pt開始起跳，一般係作為標題或主文的引導。

# 字體選擇
## 展示用標題字

### 展示用標題字的選用

關於選擇展示用字體，因為字型眾多，有人認為可任意決定。選用字體前，你必須考慮下列要素：

字體給人的視覺效果是什麼？有些字體具強烈的積極性，相對也有字體看來文雅高貴，若希望能夠反映出文章的內涵，就要利用字體特徵所給人的感覺。你希望展示用字體和內文彼此協調（也就是和內文有一致性），或是相互形成對比 （例如以襯線字體當內文，並以無襯線字體作為展示用標題字) ？

### 設計決策

1襯線字體的特徵是字臂、字幹和字尾處的筆觸皆會加重。2無襯線字體的結尾則無此特徵。3Times是常用的襯線字型，給人傳統的安定感。4具現代感的Stone Sans，和範例中的Times做比較。5有極細襯線的字體，例如Bodon。6有厚平襯線的字體，例如Rockwell。7有括弧襯線的字體，例如Century Schoolbook。8將各種字體放在一起，就可看出其中的異同。9-13以下範例為字體的視覺效果，如何反映出內容。

A serif typeface

1

A sans serif typeface

2

The tradition of a classic serif

3

The modernity of a clean, sharp sans serif

4

Bodoni
has a
hairline serif

Rockwell
has a
slab serif

Century
has a
slab bracket

bracket
hairline
slab bracket
slab

The
mechanical
achievement
of Courier

The soft
approach of
Bembo

The
AUTHORITY
of Gill

*The delicacy of*
*Copperplate Script*

The
power
of
Helvetica

## 練習 13

- 以一張A4大小的人像照版面，選用適合文章的字體，不論大小寫字母，將以下的內容置入展示標題中：
- pure poetry
- traces of conflict
- keep off the grass
- down memory lane

*pure poetry*

traces of
# conflict

## KEEP OFF
## THE GRASS

*Down Memory Lane*

Uyl en Spiegel

## 練習 14

- 這次換成以字體作為主導，用以下的字型，搭配能反映其感覺的文字：
- Bembo italic
- Helvetica bold
- Rockwell light

*Hand crafted*
*porcelain since 1851.*

**You will find a lifejacket**
**located underneath**
**your seat.**

October 18, 23.00 pm.
Suspect enters side
entrance. Visibility is poor.

1 由粗糙的手工模板結合成的影像，效果很成功。
2 字體大小排列與位置不同，經過巧妙的處理，與字意的感覺相當契合，字母間的緊湊感也產生一股張力。
3 模仿舞蹈位移效果的字體。
4 使用無襯線字體，並將字體拉大，使視野更寬闊更符合字意。

展示用標題字

2

3

有些字體因為形式上固有的質感和結構美，而被稱為「古典」字體，
經過時間的考驗，人們仍喜愛用這些古典字體作為內文字體。

# 字體選擇
## 內文用字體

### 內文用字體

需要具有易讀性的文章內文，常用
Bembo,Garamond,Caslon,Times,Pal
atino和Plantin等古典字體。

選內文用字體和選展示用標題一樣，
但是另有一項重點，就是：功能性。
換句話說，何謂文章的目的？是否可
像讀小說般流暢？文章是否會被副標
題截斷，這樣還能使讀者容易了解文
意嗎？或者，整體表面看起來比實際
想說的還重要？

在選用內文字體前有三點需要考慮:
- 字體的x-高度
- 字體的位置與字寬
- 字體的視覺效果可反映出文意

### 設計決策

**1** x-高度是字體本身的高度(以最低點**x**命
名)，小寫字體中高於**x**-高度的部份稱為上限
(例如**b**的臂部)，低於**x**高度的部份稱為下限
(例如**p**的字幹)。**2** 字體大小級數相同時，由
於**Bembo**字體的**x**-高度較小，所以看起來
會比**x**高度較大的**Times New Roman**字體
來得小。**3 Century Schoolbook**較寬長，

其所需寬度就比窄形字體**Ehrhardt**還多。**4-
6** 教導式文章：用無襯線字體表示命令或警
告，比古典字體或斜體字更具權威性。**7** 連
續性文章：每行**10**至**12**個字的古典字體是最
佳選擇。**8** 真實性文章：這種文章有標題或
副標題做斷行，且需要持續地閱讀，用無襯
線字體有助於設計，並和標題的重量產生對
應。**9-11** 雜誌編排：是否具閱讀性不在首
要，而以造形取勝，造形意味濃厚的雜誌特
別具冒險性，常用字體為**Erhardt,Stone**和
**Rotis**。

The body is the x-height

The peak is the ascender

The trough is the descender

1

Bembo has a
small x-height

Times has a
large x-height

2

The set width differs

The set width differs

3

**Keep off the grass**

4

Keep off the grass

5

*Keep off the grass*

6

Mackintosh's influence on the avant-garde abroad was great, especially in Germany and Austria, so much so that the advanced style of the early 20th century was sometimes known as 'Mackintoshismus'. His work was exhibited in Budapest, Munich, Dresden, Venice and Moscow, arousing interest and excitement everywhere. From 1914 he lived in London and Port Vendres. Thereafter, apart from a house in Northampton, none of his major architectural projects reached the stage of execution, although he did complete some work as a designer of fabrics, book covers, furniture and painted watercolours.

7

### Helvetica
Ubiquitous sans serif typeface designed by Max Meidinger and Edouard Hoffman and issued by the Swiss typefoundry, Hass, in 1957.

### Origin
It is based on Akzidenz Grotesque, an alphabet popular at the turn of the century.

8

### Ehrhardt
This typeface is based on originals from the Ehrhardt foundry from Leipzig in the early eighteenth century. An elegant serif typeface similar to Jenson, it has a narrow set width that allows more characters to the line, making it ideal for magazine work.

9

### Stone Sans
This versatile sans serif was designed by Sumner Stone in 1987 to meet the requirements of low-resolution laser printing. There are three weights available – medium, semi-bold and bold. The face harmonises with Stone Serif and Stone Informal.

10

### Rotis Semi-Sans
A popular sans scrif throughout the 1990s, Rotis Semi-Sans was designed by Otl Aicher in 1989. Condensed in structure, some characters exhibit variations in the thickness of the strokes. It is available in four weights – light, regular, medium and bold.

11

**練習 15**

- 置入四行字級4的字，再用4pt,8pt,12pt,16pt Sabon字體，從中挑選出最理想的大小。
- 用之前的字級大小，字體改為 Century Schoolbook（寬形字體），然後用像Ehrhardt的窄形字體重複這個練習。
- 兩者並置，比較其效果。

There are many factors to consider when thinking about readability and legibility of the text. These include the line length (measure), the size of type, the weight of type, the amount of leading and the size of the x-height.

There are many factors to consider when thinking about readability and legibility of the text. These include the line length (measure), the size of type, the weight of type, the amount of leading and the size of the x-height.

There are many factors to consider when thinking about readability and legibility of the text. These include the line length (measure), the size of type, the weight of type, the amount of leading and the size of the x-height.

There are many factors to consider when thinking about readability and legibility of the text. These include the line length (measure), the size of type, the weight of type, the amount of leading and the size of the x-height.

There are many factors to consider when thinking about readability and legibility of the text. These include the line length (measure), the size of type, the weight of type, the amount of leading and the size of the x height.

4pt

8pt

10pt

12pt

10pt

**練習 16**

- 用12pt大小的Bembo字體，置入內文 "The apparent size of a typefacevaries according to the x-height. "。
- 用Times New Roman字體重複做一次。
- 將兩者放在一起比較其效果。

The apparent size of a typeface varies according to the x-height.

The apparent size of a typeface varies according to the x-height.

## 內文用字體

**VERSATILE**

WebNative and

WebNative Venture allow users to access the

FullPress server over the Internet. Regardless of their location,

users can search for assets online or in archives. Everything that

WebNative displays to users comes from the heart of the FullPress server. As

soon as a file is put on the server, it is available for use. If a file is modified, the

changes are automatically made apparent through WebNative and WebNative Venture.

Unlike some systems that sit on the outside looking in, Xinet's digital asset

management solution operates right in the middle of the workflow. Because Xinet

software is based around the filesystem, it is completely and automatically

integrated into production. There is no one else optimizing workflows

and managing assets like Xinet: no one else works

so closely with the filesystem.

**"Now our server produces
twice as much due to
FullPress' efficiency and
increased business from
customers. The workflow
is definitely faster because
we don't have to double-
check our work like we
did before."**

CLAUS KOLB
Chief Executive Officer
Kolb Digital GmbH
(digital and commercial printer)
Munich, Germany

1

[ Some brief considerations on the history of the poster ]

É rica e densa de acontecimentos a já longa história do cartaz, produto considerado, ao menos ao longo do século XX, como elemento fundamental de comunicação, sobretudo ligado ao desenvolvimento e progresso das cidades e, mais em geral, da vida urbana. É, a este respeito, muito significativo que, desde muito cedo, apareçam referências à presença de cartazes como elementos decisivos de comunicação. Refira-se, a título de mero mas muito esclarecedor exemplo, que já o Daniel Defoe, no seu célebre *Diário da Peste de Londres*, descrevia há mais de duzentos anos a sua cidade, testemunhando que esta se encontrava coberta de cartazes. Sem precisar de retroceder até à época fundadora de Gutenberg ou bem procurar estudar, nas suas aspectos semiológicos ou comunicacionais, as muitas formas que o cartaz foi tomando até se volver nesta linguagem quase específica que se tornou nossa contemporânea, é preciso lembrar, ao menos, a sua época dourada, em que muitos foram os artistas que emendaram pela sua execução, assumindo-o como veículo ideal de

**The history of the poster is long, rich and eventful.** It is a product considered, throughout the twentieth century to hand, a fundamental component of the modern means of communication, especially in its field with the growth and development of cities and, in more general terms, the urban way of life. In this respect it is highly significant that references to the presence of posters as decisive factors in methods of communication appear from a very early date. For a small but very revealing example of this, take a look at Daniel Defoe's famous *Journal of the Plague Year*, where he was already describing London as being covered

1.º CONGRESSO INTERNACIONAL DE ANTÓNIO PESSEBARO | 70  Centro de Estudos Pessebaro

2

1 襯線字體的內文和無襯線字體的標題排在一起的感覺很和諧，優雅的配置使內文易於閱讀。傳統的襯線字體，以短線水平排列，讓人清晰明瞭。展示用標題的圓體字和圓形內文圖案互補，增添不少趣味。為了良好的視覺效果，編輯時要避免干擾的破壞線及字間多餘的空白，以免毀了圓的效果。

2 此為富趣味性的組合，其中一個區塊拉寬，另一個則依照慣例排列，當總字數的數量有所規範時，這種拉寬編排的方式才可被成功地運用，否則將難以閱讀……。

為了使編排的視覺效果更具新鮮感，可以從兩方向做出字體的變化：
量感和形式。其中改變字體的量感最為簡易，因為多數字體都有粗體
字，其次則是行間距與字間距設定的視覺微調。

# 編排表現
## 字體之量感、形式、行間距與字間距

**思考以下問題：**

欲改變字體重量的妙招，就是使用無襯線字體，幾乎所有的無襯線字體都有細、中、粗和特粗，雖然襯線字體也有粗版的相關字體，但在許多個案中，其字體的濃度會自動改變，影響原始設定。

在變化字體時，應避免將同類的字體混合，例如：Bembo配上Garamond。

行間距的數值，端視字體的x-高度和量感來決定。為了讓各行列排放在一起時擁有均衡的視覺空間，行間距的設定往往會有些許的不同變化，而此設定係取決於各行列之字體x高的上限與下限。

字間距意指字母與字母間的空間值之微調，字母間因為字母造形的不同，在互相搭配時勢必會產生不同的字間距數值。

**設計決策**　**1**改變字體的量感，可以有更豐富的選擇，此為**Helvetica**字體的細、中、粗範例。**2**。造形的對比效果也不錯，例如以襯線字體當內文，無襯線字體做為標題。**3**建議將同類型的字加以混合運用，例如用兩組襯線字體或兩組無襯線字體，範例中為兩組分屬不同段落的無襯線字體，**Futura**和**Helvetica**。**4**行間距的決定，在於文字間的

彼此適性。**5**負行距的行距值必小於字級大小的自動設定值，雖然可以創造視覺上的趣味感，卻往往必須犧牲文字的易讀性。**6-7**在內文的安置部分，**x-**高度影響著行間距，大部分無襯線字體的**x-**高度較大，比**x-**高度較小的字體需要更寬的行距值。**8**字距調整的功能會改變文字左起向右延展的空間值，用以突顯編排效果。**9-10**字間距調整的功能，則是為了要微調兩個字母之間的空間值，例如**A,V,W,Y**等削角佔據較多空間的字母，並列時則需要予以縮距的調整。**11**印刷上有個習慣，就是將某些字母合字，例如**f**配**i**或**f**配**l**，因為他們較適於合併在一起。

Changing weight gives options

Changing weight gives options

**Changing weight gives options**

1

# Ranged-left arrangements

If you want consistent, uniform word spacing, then a ranged-left setting style is necessary. However, if the measure is too short and the type size too big, there will be unsightly space at the end of many of the lines. Between paragraphs in this style of setting you could insert a half-line or full-line space; alternatively, you could indent the first line of each paragraph by 1 cm. You should also think about the amount of leading: remember that the readability of all typefaces is improved with leading and as a matter of course you should not use the auto setting on the computer. Always specify a specific point size for the leading.

2

# Helvetica

This is Futura. Don't mix the two.

3

**Sans serifs like Franklin Gothic have large x-heights and need generous leading.**

6

Kerning is a useful tool for controlling the space between c h a r a c t e r s.

9

**The best designers use their eyes and trust their judgement.**

4

Serifs like Bembo have small x-heights so there is no real need for generous leading.

7

AV　VA
WY　YW
AW　WA
AY　YA
VW　YV

10

**The best designers use their eyes and trust their judgement.**

5

Tracking at -10

Tracking at 10

Tracking at 30

Tracking at 50

8

fi fl
fi fl

11

**練習 17**

- 用A4大小的人像照或風景照版面。
- 用無襯線字首大寫的小寫字體，置入 "You do not have to shoot to be heard"。
- 選用適於版面的字級大小、理想的行距，而且沒有破字。
- 改變字體的重量以詮釋文意。
- 藉由負行距的設定，讓文字互相碰觸，甚至有部份重疊。
- 置入兩行"The language and Culture of Cartography in the Renaissance"，將版面填滿，並設定零行距。
- 增加行間距並改變字間距，直至調整出最佳平衡空間效果的畫面。

You do not
have to shout
to be heard

You do not
have to **shout**
to be heard

You do
not have
to shout to
be heard

**練習 18**

- 用大寫襯線字體置入"VARIOUS WAYS OF DRAWING WAVES"，注意字間的距離與字母間的距離。
- 改變字間距，藉以創造過寬或過窄的空間感，通常A,V,W是較容易產生空間問題的字母。
- 調整字距，使文字更有效地充份使用版面。
- 與原稿比較，字間距和字距調整後，彼此之間的差異。
- 任意輸入兩行大寫字，確認A,V,W等問題字搭配良好。
- 改變字距與字間距以達到視覺上的要求。

VARIOUS WAYS OF
DRAWING WAVES

原稿

WAV

WAV

WAV

1 原稿
2 字距微調
3 字距與字間距的微調

字體之量感、形式、行間距與字間距

*The Language and Culture of Cartography in the Renaissance*

*The Language and Culture of Cartography in the Renaissance*

# VARIOUS WAYS OF DRAWING WAVES

字距微調

# VARIOUS WAYS OF DRAWING WAVES

字距與字間距的調整

1

2

1 左上角的嵌入效果很好，開放性的展示用
 字體和狹窄的嵌入字體產生極佳對比。

2 這張當代設計的展示用字體安排得非常
 好，因為負行距的設定，讓數字和字母接
 連在一起，並向上及左右滿版出血，視覺
 上的趣味豐富，也兼顧了閱讀性。

在編排上，有兩種基本形式設定，第一種是以對稱著名，就是重心置於中軸，此形式較傳統；另一種則為不對稱形式，重心不在中軸，相對地較隨機也較具有創造性的張力。

# 編排表現
## 版型設定、形狀、格式和圖地關係

### 頁面設定

可以依照圖片的形式做設定，或將字體排列成不規則形狀，也可以將頁面設定成文字置中或齊右排列。

頁面格式會影響文字的排列方式：風景照格式適合寬型的內文，而人像照格式則需較短的尺寸。

眾所周知，從正向到負向，或「反白」的過程，可以為設計中加入一些衝突與戲劇效果。在不失易讀性的情況下，反白時最好使用無襯線字體，因為若使用較纖細的襯線字體，往往會在印刷過程中變得不清晰。

### 設計決策

**1-3**先確認所選的頁面格式大小合宜，人像照格式宜用短尺寸，風景照格式則用寬長尺寸，置中（對稱）的安排較傳統，但是和諧安穩，而非置中（不對稱）者，則易產生張力與現代感。**4**對稱的組合：可以兩邊對齊排版或置中安排。**5**不對稱的組合：可以將版型任意置左或置右。**6**試著避免將兩種形式混合。**7**在反白的狀況下，最好用無襯線字體。**8**若使用細襯線字體，則盡量避免在反白的情況下。**9**字體大小低於**8pt**級數時，不宜作反白效果。

Landscape formats allow wider measures to be used.

*Short measures get lost on a landscape format.*

1

Short measures look better on a portrait format.

2

Do not use long measures on a portrait format.

3

## Symmetry

Justified type aligns on both the left and the right. However, this style can look visually poor if the measure is too short, as the space between words can be excessive.

## Symmetry

An interesting variation is to centre each line of type on the type measure. When used in conjunction with a centred heading, this gives a strong, symmetrical appearance.

use a

sans

if

you can

4

7

## Range left

Ranged-left settings with an off-centred composition give an asymmetrical arrangement. This style tends to be more dynamic than a symmetrical style of setting.

## Range right

As a variation, type can be aligned on the right of the measure. This has limited use because we are used to reading type from left to right; if too many lines are set in this style, the result can be hard to read.

## hairlines
## are
## dangerous

5

8

## Stick to your style

You should never mix styles in any element of design. This looks untidy, confused and disjointed, and is difficult to follow.

## Style

Make your decision before you start work and then stick to it. You will find it far easier to achieve a stylish, clear design.

beware

of

being too small

6

9

## 練習 19

- 用A5的格式，以粗的無襯線字體置入"Keep off the Grass"，可用大寫或字首大寫的小寫字體。
- 用你認為最好的版面配置。
- 用Bodoni字體重複這個練習。
- 討論哪一種效果最好。
- 選用一篇50至60字的短文。
- 從Bodoni,Century Schoolbook,和Bembo字體中任選三種不同字體的10級數大小文字。
- 將之反白。
- 印出來並分析各字體的可讀性。
- 用細、中、粗的無襯線字體重複以上練習
- 以有趣的形狀安排同樣的內文，再試試一張圖片如何影響文章的閱讀性和外觀設計。

**Keep off the Grass**

**Keep off the Grass**

How it all started

The basic structure of the typefaces we use today was established by calligraphers at the end of the 15th century. They took their inspiration on the one hand from Roman capitals and on the other from the manuscript styles known as Carolingian minuscules, which were established in the reign of the Emperor Charlemagne in the latter part of the 8th century.

## 練習 20

- 選用A5的人像照或風景照格式，用襯線字體置入"Symmetry:The traditional typographic method of layout whereby lines of type are centered on the centrsl axis of the page.Balance is achieved by equal forces."。
- 以對稱的形式編排。
- 用無襯線字體置入"Asymmetry: The dynamic method of layout used by modernists whereby lines of type are arranged on a non-central axis. Balance is achieved by opposing forces."。
- 以活潑的方式編排。
- 觀察並比較兩者的不同。

Symmetry

The traditional typographic method of layout whereby lines of type are centred on the central axis of the page. Balance is achieved by equal forces.

**Asymmetry**

The dynamic method of layout used by modernists whereby lines of type are arranged on a non-central axis. Balance is achieved by opposing forces.

版型設定、形狀、格式和圖地關係

### How it all started

The basic structure of the typefaces we use today was established by calligraphers at the end of the 15th century. They took their inspiration on the one hand from Roman capitals and on the other from the manuscript styles known as Carolingian minuscules, which were established in the reign of the Emperor Charlemagne in the latter part of the 8th century.

### How it all started

The basic structure of the typefaces we use today was established by calligraphers at the end of the 15th century. They took their inspiration on the one hand from Roman capitals and on the other from the manuscript styles known as Carolingian minuscules, which were established in the reign of the Emperor Charlemagne in the latter part of the 8th century.

### How it all started

The basic structure of the typefaces we use today was established by calligraphers at the end of the 15th century. They took their inspiration on the one hand from Roman capitals and on the other from the manuscript styles known as Carolingian minuscules, which were established in the reign of the Emperor Charlemagne in the latter part of the 8th century.

It came from
## outer space

Irregular shapes are easy to achieve with computer setting. They will add visual interest to a piece of text and at the same time they can reflect the contents.

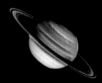

It came from
## outer space

Irregular shapes are easy to achieve with computer setting. They will add visual interest to a piece of text and at the same time they can reflect the contents.

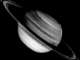

It came from
## OUTER SPACE

Irregular shapes are easy to achieve with computer setting. They will add visual interest to a piece of text and can reflect the contents.

尺規（線條）和裝飾所扮演的功能，是引導讀者的目光，吸引至圖文頁
面中最特別的部分，同時也是一種潤飾。

# 編排表現
## 輔助尺規與裝飾圖案

### 在內文與展示用標題中的應用

尺規可以運用的粗細範圍和樣式繁多
（連續線、虛線、破折號），其寬度則
由0.5點（極細線）向上增加。當用作
串聯文章時，尺規有助於讀者取得訊
息，並做項目分類。垂直運用上，可
將文章分成多欄位，水平運用上，則
可組織訊息並有助於閱讀，同時，也
可作為重點字的強調線。

在編排表現上，尺規可以創造戲劇和
表演效果成為焦點線索。若尺規夠
寬，則可將字體在其上反白。在海報
設計上，尺規還能扮演訊息識別符號
的角色。

自中世紀起，印刷業者和設計師就常
用花朵做為頁面裝飾，中世紀的書頁
上總是有著手繪花邊，嵌入Zapf
Dingbats是最常用於裝飾文章的方
法。

### 設計決策

1表格形式中，尺規的功能是將訊息加以
歸類。2尺規可在逐項觀看時，扮演協助
的角色。3尺規對目錄頁有極大的幫助。
4在展示用標題的編排中，字體下的標線
可與其成對比，例如，在36pt的**Univer
light**字體下加上極粗的線，或在粗黑的
字體下畫上細線。5文章中的重點可以用
尺規做強調，引人注目。6裝飾圖紋散發
出的傳統感。

| Title | Name | | |
|---|---|---|---|
| Address | | | |
| | | | Postcode |
| Email | | | |
| Tel | | Fax | |

1

Series D

| | | | | |
|---|---|---|---|---|
| **The Fairy Queen** | 10 | September | 20.30h | 2 |
| **Ariadne auf Naxos** | 23 | October | 20.30h | 19 |
| **Recital Gosta Winbergh** | 7 | January | 20.30h | 53 |
| **Norma** | 14 | January | 20.30h | 59 |
| **Pikovia Dama** | 7 | February | 20.30h | 67 |
| **Il viaggio a Reims** | 12 | March | 20.30h | 78 |
| **Orfeo ed Euridice** | 16 | April | 20.30h | 96 |

2

# Contents

3

In magazine work, typographers must constantly look for ways of attracting attention and stimulating the reader.

## Rules draw attention to subheads

The way subheadings and headings are positioned is one method of bringing the reader into the text. Rules can give dramatic tension to a heading.

5

Univers
Light

4

**Univers
Black**

BRITISH PAINTING

1948–1964

6

**練習 21**

- 用A5的格式，設計任何一本書中的目錄頁，字體大小、測量和行間距由你斟酌，頁碼齊右。
- 利用同樣的版面，在每個項目下加上極細線或1pt的線條。
- 討論兩者的效果。

**Contents**

**Contents**

**練習 22**

- 用練習21中的版面大小，置入三次三行字"Rules have Power"，可用大寫或字首大寫的小寫字體。
- 第一個範例用36pt細的無襯線字體，下標線用12pt。
- 然後用36pt中粗的無襯線字體，下標線用6pt。
- 用36pt粗的無襯線字體，下標線用1pt。
- 分析彼此的不同。

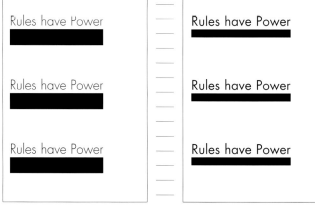

輔助尺規與裝飾圖案

1 這個範例，係尺規如何和不同大小的文字相應用。在標題文字中，尺規強化了文字並且賦予造形裝飾。特別有意思的是，尺規巧妙地穿過標題字的底線。

2 在標題上下畫線有聚焦的效果；下標線內的文字增加了被閱讀的機會，順著文章輪廓的垂直標線，則提供清楚的網格結構，並在易讀性上達到最佳效果。

色彩是設計者所要處理的編排物件中，最令人振奮的視覺元素。它使設計更加多采多姿，並擴展了視野，而今日的設計師何其幸運，軟體程式的開發，使色彩的運用更為簡易，豐富度也勝於以往。

# 色彩搭配
## 訊息的呈現

### 色彩選擇

正如字體單元般，色彩的象徵意義也有其重要性，例如紅色帶人聯想到火焰、溫暖、熱情，藍色則是平靜、冷酷。色彩的運用影響設計氣氛，與讀者的反應。

特殊混色也能製造氣氛，用色相環上相鄰的類似色，可營造和諧的氣氛，例如藍和綠。畫面中若需要更多的張力與活力，則要使用如紅色綠色等對比色，這種搭配雖然不調和，卻可立即引起共鳴。

### 設計決策

**1-2**有些顏色為前進色，有些則為退後色，如果你想和讀者拉近距離，紅和橘等暖色會是比較好的選擇。**3-4**藍和綠放在紅色旁邊時，會有退後感。**5**色相環上相鄰的顏色類似色，如黃和綠、藍和綠；色相環上位置相對的顏色為互補色，如紅和綠、黃和紫，這種色彩搭配較有活力。**6**黃色比紅色較柔和不刺眼。**7**此為不同色相的濃度變化（參考58頁），字體也可以用相同色調做不同變化。

advance　　advance

recede　　recede

1　2　3　4

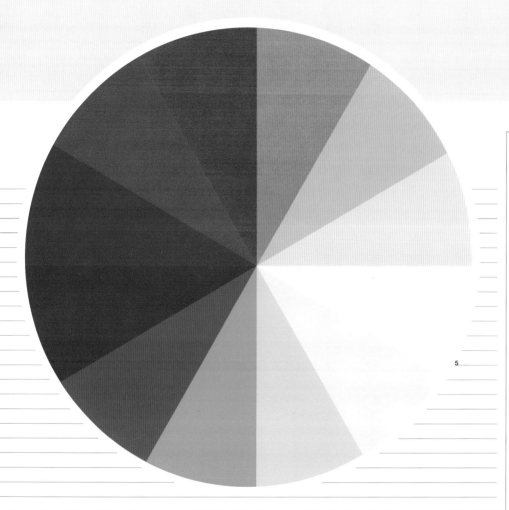

5

There are many intensities

# rock'n'roll

# **rock'n'roll**

# rock'n'roll

# rock'n'roll

# rock'n'roll

**Do these colours advance or recede?**

7

I'm red and aggressive

I'm softer in yellow

6

**練習 23**

- 用A6的格式，置入大寫粗體無襯線字體"BRAVO"，用鮮紅色列印。
- 重複這個練習，將字改成青色。
- 將兩者印出並作比較。
- 用同樣的格式、字體和大小，置入"JAZZ BAR"。同先前的步驟，字體用紅和藍色，但這次請用不同的色相來表現後退色。

# BRAVO!

# BRAVO!

JAZZ BAR

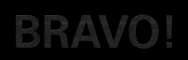

**練習 24**

- 用練習23中的版型、字體和色彩，將背景改為黑色和黃色。
- 重複以上步驟，自選文字和色彩，看看搭配不同背景及不同訊息所產生的影響為何。
- 列印出來並互相比照。

# BRAVO!

# BRAVO!

# JAZZ BAR

# JAZZ BAR

訊息的呈現

1. 色彩在展示用標題和內文中，可作為區分類別的工具，此範例就有效地顯示：兩種語言反轉成同一色調是相當容易的，同時還能增加設計的重要性。

2. 此範例的用色極佳，"inside"這個字向背景退去，對原稿的涵意做了最好的反映。

3. 範例中的兩個主色，展現出設計概念可以藉由色彩的應用來強化，此外，色彩亦能使畫面的定義更加分明。

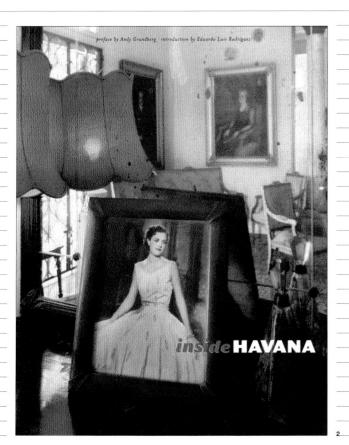

雖然色彩能夠帶來各種可能性，但仍要有所節制：就是不要濫用色彩，否則色彩的影響力便會抵消。

# 色彩搭配
## 段落區別和易讀性

### 色彩術語

以下為三個色彩的常用術語：色相－純色（如紅、藍、綠等）；明度－色彩濃淡；以及彩度－從高飽和度（例如鮮紅色）到低飽和度（例如深綠色）之間的色彩範圍。

在使用字體和色彩時，易讀性往往產生自圖地之間的強烈對比，黑底白字的對比最強烈；白底黃字的對比最小。可用的色彩範圍極大，若背景和字體的顏色太相近，便易失去可閱讀性。

### 設計決策

**1** 三種和色相相關的術語。**2** 色相，色彩的名字。**3** 明度，從明到暗的範圍。**4** 彩度，色彩強度從低到高的範圍。**5-6** 白底黑字或黑底黃字的對比最強烈。**7** 白底黃字的對比度低。**8-10** 若背景和字體的顏色太相近，便易失去可閱讀性。**11** 字體設計也影響色彩的效果，如襯線字體無法承載較大面積的色彩，會減弱飽和度，使色彩顯得較淡。**12-13** 無襯線或粗厚的字體，較適於承載色彩，保持色彩原有的強度。

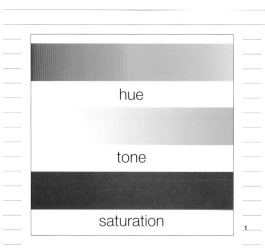

1

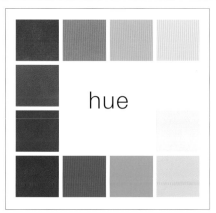

2

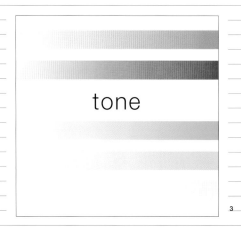

3

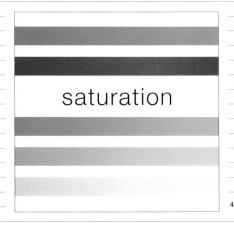

4

5

6

7

8

9

10

11

12

13

**練習25**

- 選擇一個A4橫式格式。
- 將文字'OK!'以無襯線粗體字表現。將字體以黃色印於白色的背景上。
- 重複練習,將顏色以光譜表現－橘,紅,綠,藍和紫色。
- 分析你的結果,實驗色彩在視覺上的前進和後退。
- 以背景和字體的色彩作實驗,來達到最小或最大的對比。

**練習26**

- 以練習25同樣的格式,將文字'Bar Manager'以12pt Bembo字體表現於白色背景上。
- 重複練習,將字體改變為12pt無襯線粗體字。
- 比較兩個不同的列印輸出,決定哪一個色彩較為強烈。

## 段落區別和易讀性

1 色彩看起來很和諧是因為顏色的飽和度高；同時也使這個畫面予人一種大膽的印象。

2 使用色彩來表現前進後退的良好範例。以簡單的背景色彩變化來詮釋整體視覺設計的轉換和不同角度的認知。

3 色調上的使用使顏色變得較柔和，並且表現出較清新的氛圍。而角落橘色調的使用，則給予整個設計更廣闊的感覺。

4 兩種非常強烈的色彩形成了一種侵略性的感覺。

1

2

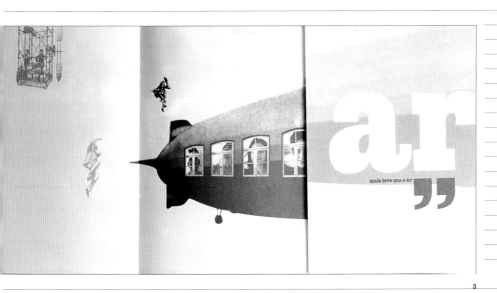

3

4

藉由現今日趨精密的電腦及列印輸出技術，可以更快速且輕鬆地將字
體、色彩和圖片作混排實驗，甚而產生新奇的結果。

# 色彩搭配
## 字體、色彩和圖片的混排

### 色彩衝擊

生產線上的機器有5至6色，所以設計師可以有效地利用基本4色(CMYK)，加上1至2種特殊色，達到最佳的色彩效果。

CMYK是一種分色系統，為青(cyan)，洋紅(magenta)，黃(yellow)和黑(key;black)，這種系統主要應用於印刷，所有的其它顏色皆由CMYK四色組合而成。

Pantone色票是印刷常用的標準色彩依據，印刷業者和設計師可以參考其色彩編號加以運用。

這些系統使設計師能全然地運用色彩，再造藝術品或相片原色。

做為背景的色彩必須要能與字體融合，並加以襯托出字體，例如一個方框，用20%黃的淺色調填滿，這與黑色的內文是極佳的搭配，若將背景色做成漸層，則又是另一種視覺刺激。相似的不同顏色及漸層的相同色，可以用來突顯內文，為達易讀性的目的，則僅會單純地使用色彩的濃淡來襯托較大的展示用字體。

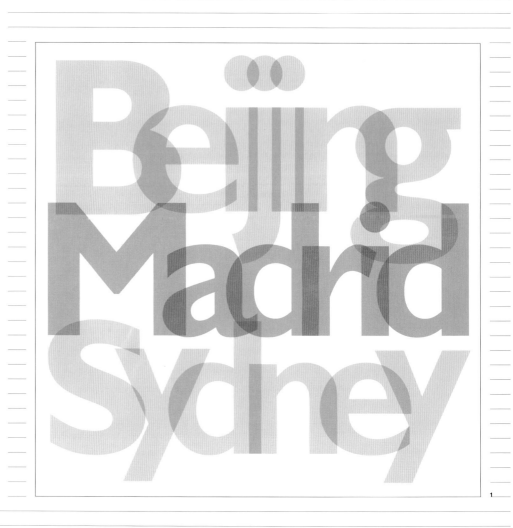

1

**設計決策**　　**1**在大型展示用標題中，當字母重疊時，會產生另一種新的趣味造形。　**2**當兩種顏色重疊時，第三種顏色的出現會增加視覺效果。　**3**將白色內文字放在天空藍的背景上，可突顯其對比效果，增加其易讀性；以文字反白形式利用照片的空間，不失為一種經濟法。**4**微妙地在背景上色，使文字具有更美觀的呈現。　**5**　在四周加上彩色框線，也是增加畫面變化的方式之一。　**6-8**色彩漸層也會增添視覺的趣味。

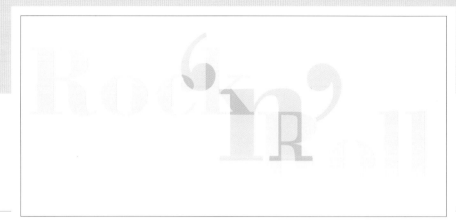

2

3

## The creativity of colour

Colour attracts the reader: it opens up the whole design and gives an added dimension to the visual look of a piece. By changing the density of the colour you are using, you can make it look as if another colour is being used — and, of course, it creates contrast within the overall composition.

4

## The creativity of colour

Colour attracts the reader: it opens up the whole design and gives an added dimension to the visual look of a piece. By changing the density of the colour you are using, you can make it look as if another colour is being used — and, of course, it creates contrast within the overall composition.

5

## The creativity of colour

Colour attracts the reader: it opens up the whole design and gives an added dimension to the visual look of a piece. By changing the density of the colour you are using, you can make it look as if another colour is being used — and, of course, it creates contrast within the overall composition.

6

## The creativity of colour

Colour attracts the reader: it opens up the whole design and gives an added dimension to the visual look of a piece. By changing the density of the colour you are using, you can make it look as if another colour is being used — and, of course, it creates contrast within the overall composition.

7

## The creativity of colour

Colour attracts the reader: it opens up the whole design and gives an added dimension to the visual look of a piece. By changing the density of the colour you are using, you can make it look as if another colour is being used — and, of course, it creates contrast within the overall composition.

8

## 練習 27

- 用A5的風景照格式。
- 用數個數字，以夠大的字級將空間填滿。
- 選出兩個主色。
- 數字用不同顏色相重疊，重疊處產生另一種新形狀。
- 兩主色相疊處產生第二色。

## 練習 28

- 用練習27的格式，做出一個7.5公分的正方形，並用20%的黃填滿。
- 用10pt無襯線字體置入30個字。
- 字用黑色，背景用20%的黃。
- 重複以上練習，並在正方形四周加上2pt，60%黃色的框線。
- 逐次增加背景的明暗度。
- 檢討實驗結果。
- 用相同大小的正方形，並用單色從上而下做漸層。
- 嘗試搭配背景和字體的顏色。

One of the big advantages of using a computer is the speed with which you can change the look of the design. It is easy to experiment with background and text colours.

One of the big advantages of using a computer is the speed with which you can change the look of the design. It is easy to experiment with background and text colours.

One of the big advantages of using a computer is the speed with which you can change the look of the design. It is easy to experiment with background and text colours.

One of the big advantages of using a computer is the speed with which you can change the look of the design. It is easy to experiment with background and text colours.

1 善用色彩變化的範例；色彩可輔助區分內文，也可增加更多視覺意義。

2 用色彩強調主題是很聰明的做法，範例中的鮮明色彩便是最好的證明。

3 中間調的使用讓內文和影像更加和諧，減少畫面上的衝突。

4 圖片中暗色的人物為柔和色與對比色的巧妙應用。

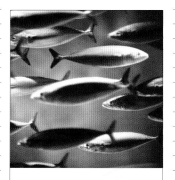

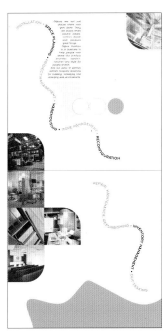

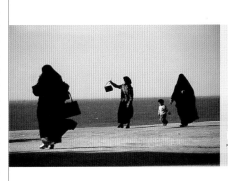

當你在決定字體以前，需要先決定文章中訊息重要的優先序。建立版面編排中的分級制〔強調的順序〕，能夠使你了解在處理資料時會面臨多少不同的階段步驟。

# 訊息分析
## 編排的層級

### 級別的重要性

標題方面你可能會使用三種不同的級別，分為A，B和C。內文編排也可規範為此種形式，並套用於不同重要層級的資料。

不同級別的展示標題可由字級和字寬的變化來決定。不同的大小是用來區分內容重要性的一種方式，字體的改變（如將無襯線字體改為襯線字體）則往往會形成視覺上的趣味性。此外，你還可以透過顏色的變化來輔助設計。

### 設計決策

**1**這個音樂節目有五種級別的重要性：節目號碼，日期，時間，作曲，音樂和演奏者的類型。**2**形式〔如：將正體字改為斜體字〕和顏色的對比，是實現視覺清晰目標的好辦法。**3**字形的對比。**4**當標題和內文相組合時，常用不同的字級大小和字形使段落分明。**5**尺規也可作為分段的重要依據。**6**區塊可以用來強調段落文章。

---

**37 Saturday August 17**
7.30pm–9.50pm

**Rodgers, orch. Hans Spialek** Babes in Arms – Overture **Rodgers, orch. Robert Russell Bennett** Victory at Sea – Symphonic Scenario; On Your Toes – Slaughter on Tenth Avenue **Rodgers & Hammerstein** Oklahoma! (concert version)
Maureen Lipman, Lisa Vroman
Klea Blackhurst, Tim Flavin, Brent Barrett

1

---

**Wednesday**

● **Susan Bullock**
Soprano joins the South Quarter Sinfonia for works by Ravel and Wagner.
*St Mark's Chapel (07 22 1061)*
*7.30pm £8–£15.*
● **Ian Fountain**
Piano works by Beethoven.
*St James's church (02 38 0441)*
*7.30pm £7–£13.*

2

---

# 36
**FAMILY FAVOURITES**
Cornish Ware brought to book.

# 38
**LATE QUARTET**
Linen Works: a group of weavers with more than one string to their bow.

---

# 42
**TIME FOR CRAFTS TO GO TO THE BALL**
Arts for Everyone – will the new lottery scheme live up to its name?

# 44
**SOURCES OF INSPIRATION**
The sculptor Bryan Illsley talks about his life and work.

---

3

## House Specialties

SERVED WITH PILAU RICE

### *Chicken Passanda.........£6.50*

A mild and delightful dish, specially cut slices of chicken marinated with yoghurt based sauce and cooked in fresh cream, mixed ground nuts and almond powder.

### *Karhai Lamb...............£6.50*

Tender pieces of lamb grilled in a tandoori oven, cooked with garlic, ginger, tomatoes, onions, capsicum and fresh coriander, medium spiced.

### *Karhai King Prawn.......£8.95*

### *Achar Gost.................£6.50*

A fairly hot dish. Pieces of marinated lamb cooked in a tantalizing pickle masala, laced with whole green chillies.

### *Amere Murgh..............£6.50*

A delightful mild chicken dish, cooked with pulp mango, mild spices, fresh cream and almonds.

4

## Best Saving Rates

**Find the best deals on savings accounts**

| PROVIDER | PRODUCT | GROSS RATE |
|---|---|---|
| **£1/£10 to invest** | | |
| Rock | Online Saver | 3.35 |
| Net | Online Saver | 3.05 |
| Local Friendly | Immediate Access | 3.00 |
| **£1,000 to invest** | | |
| Southern Reliant | Saver Plus | 3.40 |
| Roots | Online Saver | 3.35 |
| BankDirect | Saver Plus | 3.22 |
| **£25,000 to invest** | | |
| BankDirect | Midi Longterm | 3.40 |
| Roots | Saver Plus | 3.35 |
| Local Friendly | Midi | 3.25 |
| **£50,000 to invest** | | |
| Roots | 30 Day Access | 4.20 |
| Net | 3 Year Access | 3.75 |
| Local Friendly | 2 Year Access | 3.55 |
| Southern Reliant | Midi Mini | 3.45 |
| Lane and Lane | Midi Saver | 3.40 |
| **Over £50,000 to invest** | | |
| Lane and Lane | Midi Maxi Longterm | 5.55 |
| Northern Circle | Fixed Saversure | 5.20 |
| Southern Reliant | Fixed Saversure | 4.75 |
| Local Friendly | Saversure Access (variable) | 4.70 |
| Net | Premier Plus | 4.65 |

5

# DVD & VIDEO

### The Magnificent Seven
*Stylish*

Starring: Steve McQueen, James Coburn, Charles Bronson, Robert Vaughn and Yul Brynner. The beleaguered denizens of a Mexican village, weary of attacks by banditos, hire seven gunslingers to repel the invaders. This is without a doubt a film to remember.

### Gone with the Wind
*Old classic – not to be missed*

More than a movie: this 1939 epic (and all-time box-office champ) is superbly emotional and nostalgic. Vivien Leigh is magnificent; Clark Gable provides one of the most charismatic performances ever. It's an achievement that pushed its every resource – art direction, colour, sound, cinematography – to new limits.

### A Beautiful Mind
*High interest*

A decent biopic of the Nobel prize-winning mathematician, John Nash. It doesn't come close to conveying the contribution Nash made to economics, and it's really just Shine with sums, repeating as it does one of Hollywood's favourite equations – genius equals madness.

6

## 練習 29

- 使用A5的直式頁，編排大約200個字，字體大小為9或11pt的文章。
- 分析文章的內容並且寫下它的主標題、次標題及任何你覺得重要的部分。
- 使用相同格式，將下列資料以不同的字級、字型及字寬分成八個編排層級：1/FridayJuly19/7:30pm/Haydn/The Creation/featuring/Christiane Delze/Soprano
- 試驗各種字體、色彩和形式。

Each year the second year students, in conjunction with their Contextual Studies program, produce a course magazine. The subject matter relates to the design industry. Each student is required to write approximately 500–750 words on a subject of choice, research the appropriate visual material, and bring these elements together in a design for a double-page spread.

The objective of this project is to enable students to oversee a complete concept from the selection of the subject matter and writing of an article, to the design and production of the magazine.

Students are encouraged to: use their writing skills; analyse subject matter; make constructive critical comments.

The subject matter for the article is of the student's own choosing, thus motivating them to choose a subject of interest. This in turn encourages care and clarity in the treatment of the text and the use of language.

The work is assessed according to the following guidelines: the student's ability to evaluate in written form a design topic; the application of appropriate visual material to improve the article and provide an effective design; ability to meet production deadlines.

## Magazine Design Project

Each year the second year students, in conjunction with their Contextual Studies program, produce a course magazine. The subject matter relates to the design industry. Each student is required to write approximately 500–750 words on a subject of choice, research the appropriate visual material, and bring these elements together in a design for a double-page spread.

**Aims and Objectives:**
The objective of this project is to enable students to oversee a complete concept from the selection of the subject matter and writing of an article, to the design and production of the magazine.
Students are encouraged to:
- use their writing skills
- analyse subject matter
- make constructive critical comments.
The subject matter for the article is of the student's own choosing, thus motivating them to choose a subject of interest. This in turn encourages care and clarity in the treatment of the text and the use of language.

**Assessment criteria:**
The work is assessed according to the following guidelines:
1. The student's ability to evaluate in written form a design topic.
2. The application of appropriate visual material to improve the article and provide an effective design.
3. Ability to meet production deadlines.

## 練習 30

- 選一篇大約200字的文章，在A5的頁面上，使用10pt大小的Times字體。
- 了解文章的內容並加入主標題和次標題，藉以表示出其優先序。
- 在A4方形紙上設定兩欄位的網格，並注入內文、標題及式樣。
- 相同版面且同樣設定兩欄位的網格，注入內文、標題、式樣，附加兩張圖片。

Graffiti is a contentious subject. It can be viewed either as vandalism or as an art form. On the one hand people argue that it damages our environment and should not be condoned; on the other hand it is seen to have an intense energy and creativity. Whatever your opinion, you cannot ignore the fact that graffiti is now part of urban life. The essence of the best graffiti can be utilised as a starting point for design concepts. Speed, vigor, and excitement are inseparable from graffiti art. This is because it is usually an illicit activity. Its clandestine nature is in itself a motivating force and dictates the type of equipment used: spray cans or broad-tipped markers – easily carried, effective, and fast. The rich visual dynamism of designed mark-making conveys a great sense of enjoyment that may well be echoed in the viewer: Graffiti has many lessons to offer in color and pattern. There are uses and applications for this questionable street art. Urban locations have been designated for this very purpose. Record covers, posters, comics, and badges use this medium to capture the essence of a message and convey it in an interesting and powerful way.

## Graffiti

Graffiti is a contentious subject. It can be viewed either as vandalism or as an art form. On the one hand people argue that it damages our environment and should not be condoned; on the other hand it is seen to have an intense energy and creativity.

**Not to be ignored**
Whatever your opinion, you cannot ignore the fact that graffiti is now part of urban life. The essence of the best graffiti can be utilised as a starting point for design concepts. Speed, vigor, and excitement are inseparable from graffiti art. This is because it is usually an illicit activity. Its clandestine nature is in itself a motivating force and dictates the type of equipment used: spray cans or broad-tipped markers – easily carried, effective, and fast.

**Street art**
The rich visual dynamism of designed mark-making conveys a great sense of enjoyment that may well be echoed in the viewer: Graffiti has many lessons to offer in color and pattern. There are uses and applications for this questionable street art. Urban locations have been designated for this very purpose.

Record covers, posters, comics, and badges use this medium to capture the essence of a message and convey it in an interesting and powerful way.

## 1

**Friday July 19** 7.30 pm

# *Haydn*

## The Creation

FEATURING

Christine Delze

*Soprano*

---

HAYDN

*The Creation*

FEATURING

## Christine Delze
Soprano

**FRIDAY JULY 19**
**7.30 PM**

---

## Graffiti

Graffiti is a contentious subject. It can be viewed either as vandalism or as an art form. On the one hand people argue that it damages our environment and should not be condoned; on the other hand it is seen to have an intense energy and creativity.

**Not to be ignored**
Whatever your opinion, you cannot ignore the fact that graffiti is now part of urban life. The essence of the best graffiti can be utilised as a starting point for design concepts. Speed, vigor, and excitement are inseparable from graffiti art. This is because it is usually an illicit activity. Its clandestine nature is in itself a motivating force and dictates the type of equipment used: spray cans or broad-tipped markers – easily carried, effective, and fast.

**Street art**
The rich visual dynamism of designed mark-making conveys a great sense of enjoyment that may well be echoed in the viewer: Graffiti has many lessons to offer in color and pattern. There are uses and applications for this questionable street art. Urban locations have been designated for this very purpose.

Record covers, posters, comics, and badges use this medium to capture the essence of a message and convey it in an interesting and powerful way.

---

## Graffiti

Graffiti is a contentious subject. It can be viewed either as vandalism or as an art form. On the one hand people argue that it damages our environment and should not be condoned; on the other hand it is seen to have an intense energy and creativity.

**Not to be ignored**
Whatever your opinion, you cannot ignore the fact that graffiti is now part of urban life. The essence of the best graffiti can be utilised as a starting point for design concepts. Speed, vigor, and excitement are inseparable from graffiti art. This is because it is usually an illicit activity. Its clandestine nature is in itself a motivating force and dictates the type of equipment used: spray cans or broad-tipped markers – easily carried, effective, and fast.

**Street art**
The rich visual dynamism of designed mark-making conveys a great sense of enjoyment that may well be echoed in the viewer: Graffiti has many lessons to offer in color and pattern. There are uses and applications for this questionable street art. Urban locations have been designated for this very purpose.

Record covers, posters, comics, and badges use this medium to capture the essence of a message and convey it in an interesting and powerful way.

有時候，插畫或圖表會比相片更具有說服力、更能使主題呈現戲劇化
的效果。

# 訊息分析
## 插畫和圖表

### 插畫或圖表的功能

在平面設計中，插畫可以簡化繁雜的
文章內容，利於傳遞訊息，因為，插
圖可以協助讀者超越語言的隔閡，產
生更真切的情感回應，甚至描繪出不
存在的情境。

設計師可以運用電腦繪製圖表或地
圖，但必須事前做好版面的構成規
劃，並確定文字與圖表都能易於被閱
讀，記住一句古諺：「少即是多」。

### 設計決策

**1**地圖是圖表中用以傳遞訊息的實例之一，
透過**3D**製作物件，顯得特別清楚。**2**插畫
可用以解釋物件，像相機這種複雜的裝
備，用簡圖標明局部構造，可讓人避免混
淆。**3**繁雜的文章內容，可藉由插畫使人一
目了然。

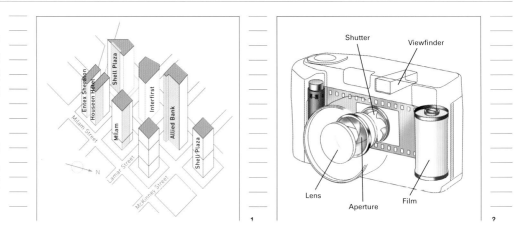

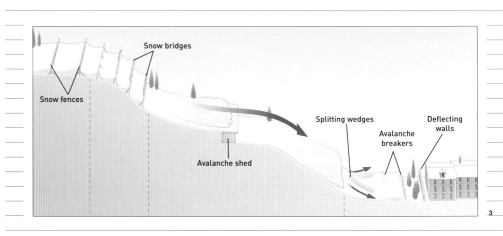

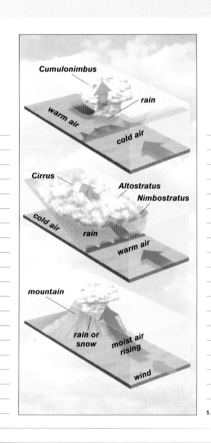

1 這張簡單明瞭的示意圖傳達出
很多訊息，若完全以文字表
現，將會令人感到費力且難
懂。

2 此範例顯示圖表對影像的影響
力；箭頭符號與圖像適時地強
調出畫面的重心。

## 練習 31

- 用一張A5的人像照版面，
  設計一張從你家到圖書館
  的地圖，在運輸系統上標
  示重要的地標。

- 設計一張地圖，標明文化
  活動的所在地，包括教
  堂、歷史建築、電影院、
  劇院、俱樂部、酒吧等。
  如果需要的話，還可以加
  上關鍵字的輔助說明。

## 練習 32

- 用與練習31相同的格式，
  設計出每大連續的經驗，
  例如泡茶、查閱書本檢
  索、水煮蛋、縫鈕釦或栽
  種植物。

- 以4到8格步驟設計他們之
  間的序列性，每格約 5 公
  分見方。

- 為每格加上說明文，排列
  在A5的版面上，再加入適
  當的標題。

### Potting Plants

When you buy a new plant, remove approximately one-third of the growth and thin out the branches. This will give the plant a good basis for growth.

The root system will be enormous when new. In spring, reduce the root system by one-third so that the plant does not become pot-bound.

If you wish to transfer the plant into a new pot it is best to do this when root pruning. Allow the foliage to grow quite freely at this stage, this will help the plant to establish itself within the new pot.

Keep trimming the branches to encourage the plant to grow. Sunlight and occasional watering are also required to keep your plant in peak condition.

插畫與圖表

1 這張複雜的設計有效地傳達出訊息，內文尺寸的改變，和圖文整合的構圖很引人注目。

2 改變訊息項目中字體的色彩與字寬，能夠形成視覺上的衝擊，而右側的地圖也是簡而易讀。

3 "Design is a way of looking at and improving the world around us"這段內文的搭配極佳，是和諧與平衡的示範。

4 模糊超大標題字的焦點，這種做法相當聰明，因為可以讓觀者將注意力轉移到字間空白處的細小內文。

由於人們習慣透過電視或出版品，閱讀影像化的人生百態，相較於插畫，攝影顯然更能傳達寫真效果。因此，設計師往往傾向於藉由攝影手法，來表現設計概念。

# 影像運用
## 工作程序的安排

### 攝影實務應用

你可以自行拍攝、雇用專業攝影師，或透過攝影資料圖庫取得影像作品。你也可以利用先進電腦軟體，例如 Adobe Photoshop的應用，來創作或提昇影像資料的品質。

想要有效地使用影像，必須先理解如何創造生動的編排效果，充份了解並妥善安排圖文關係是極其重要的前題。

### 設計決策

有很多種設計技巧可以用來輔助照片的運用。**1**照相拼貼法可以讓你將許多不同的設計元素排列組合在一起。**2-6**像**Adobe Photoshop**之類的電腦軟體，可以提供多元的特效，讓你創造出更豐富的影像魅力。**7**單純的黑白影像，也能製造出生動豐富的單色漸層效果。**8**反常和意想不到的構圖手法，可以增加視覺的衝擊力。**9-12**隨興地剪裁照片形狀，偶爾也能為設計帶來新意。

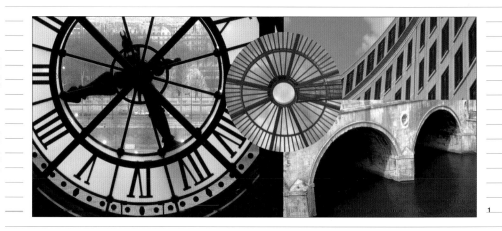

1

2

3

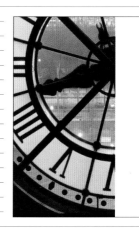

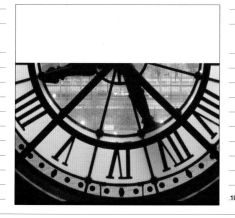

## 練習 33

- 使用A4大小的格式，設計整版跨頁的雜誌內頁。
- 主題是動態的。選擇任何一項專業或非專業的運動項目，或者是任何關於人或動物的動態圖片。
- 盡量從越多的照片中作選擇。
- 決定六至八張照片為製作項目，盡量使用不同內容的相片，並為每張照片寫下說明文字。
- 設計網格來規劃照片及說明文字。
- 使用你的影像和說明文，製作一個主題、照片形狀及圖像大小之對比強烈的動態版面。

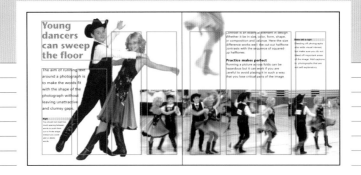

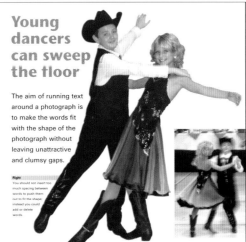

## 練習 34

- 使用和練習33一樣的大小格式與網格，將主題改為你的家鄉或城鎮。
- 使用六至八張對你具有吸引力的照片。物件的內容可以是建築物、當地居民、街頭標誌等任何可以表現居地特色的元件。
- 試著加強物件比例，及形狀的對比。
- 為每一個影像寫一段說明文字。

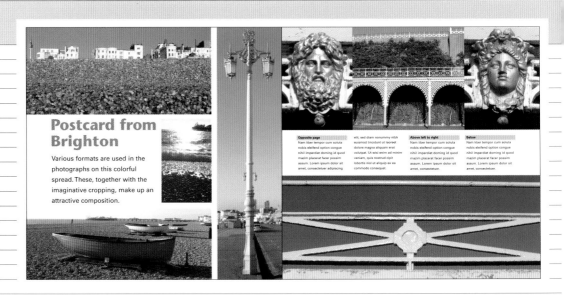

## 善用攝影作品

1 小型的照片和畫面結合得很好。

2 照片是用來呈現真實感的重要元素，尤其是用於表現食品。

3 良好色感的攝影作品可以突顯主題，並且充份反應內容。

4 善用影像比例，可以增加設計上的趣味。

5 一個有想像力的攝影師可以提昇設計水平，並且增加視覺張力，例如這件銷售簡介。

要如同它們被拍攝下來的樣子，忠實使用照片是很困難的。如果要以不同的格式來使用照片，往往無法再特別設計適合它們的欄位，此外，照片包含許多細節，可能會分散了對主要目標的注意力，所以必須更重視照片的裁切。

# 影像運用
## 照片的裁切與比例

### 如何進行設定

網格的建構(參考30頁)必須能適合你大部分的照片，這可以讓你就照片的形狀、大小和組合作一些構思。為了要創造出平衡及和諧的編排，照片往往要顧及全部的格位。

格放裁切可以突顯照片的特點，以符合你要的感覺。一開始先選定好要表達的主題，讓它盡可能放大並且刪除不必要的部份，等裁切完不需要的部份後，再將照片調整到適合預設格位的大小。

### 設計決策

1這張照片包含了太多細節，對主題形成干擾。2裁切這張相片加強它的效果。3-8這一系列的圖片，顯示了簡單的照片經過裁切所產生的轉變。9背景的細節會形成干擾。10藉著將照片圍在一個特定的區域，你可以輕易地突顯其故事性。11移除背景只留下主題，可以明顯地改善影像效果。

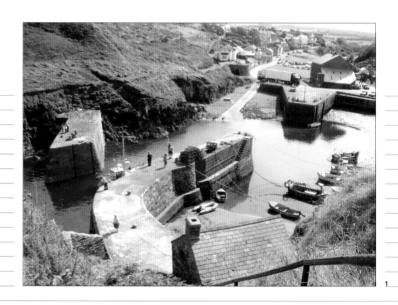

1

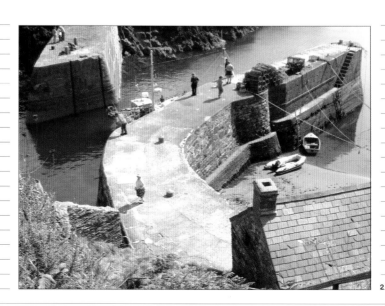

2

## 練習 35

- 選擇一張有動態人物的照片。
- 選擇一個合適的格式並且複製影像。
- 現在以連續漸進的方式將影像中的人逐次移除，最後只留下一個人。

## 練習 36

- 找一張家庭照並且將照片以合適的形狀進行複製，留下背景的細節。
- 接下來，裁切照片讓人的影像越大越好。使人成為畫面的主要焦點，留下背景細節。
- 複製相同的影像，不過這次只留下人物。

## 照片的裁切與比例

1. 每張照片經過裁切後，會在視覺上產生不同的故事性。
2. 焦點是照片的重要元素。
3. 影像大小的比例容易製造氣氛並吸引目光
4. 合成照片是可以予人想像力的有趣設計，挖剪後的形狀使作品更加生動。

當你結合文字與圖像時，套印文字在影像上是常用的試驗，但它常常
會妨礙到圖像的表現。在編排設計原理中，應該儘量讓文字離開圖
像，至少也要避開圖像中最主要的部分。

# 圖文整合
## 文字與圖像的編排組合

### 版面的基調和位置

試著選擇適合畫面情感基調的字體。
譬如說，一個積極而有力的圖像也許
需要較粗黑的字體，相反的，若是較
柔性的圖像就需要靠較輕、較纖細的
字型來突顯，像Garamond和Caslon
之類的細斜體字就很適合。

文字定位是編排時的重要關鍵。仔細
分析圖像的特質，並找出其中可以用
來引導文字排列的元素，是使圖文編
排更融洽的方法之一。

### 設計決策

1圖像的主題必定包含明確的角度與方向，
讓你能夠與文字相呼應。2讓圖像和文字呈
對比的角度排列，可以做出更生動的版
面。3圖像的內容可以讓你決定出文字和影
像的相對大小關係。4圖像和文字哪一個是
重點？5如果空間太擠，你可能需要將文字
置於圖像之上，請確認文字不會影響影像
的內容或是使焦點變得模糊。

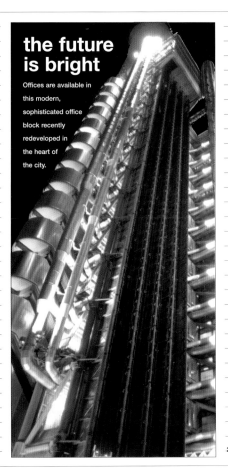

3

4

5

## 練習 37

- 使用A4的格式，選一張動態圖像並加上標題及描寫的內文。
- 以非對比的方向組合文字與圖像。

## 練習 38

- 使用練習37的圖片及內文，重新擺放標題和內文，讓它們和圖像形成不同的方向。
- 選出不同的圖片、標題和內文，使用有襯線字體，設計出和諧的版面編排。

- 重複這樣的練習，學習如何讓字體與圖像相契合。

## 文字與圖像的編排組合

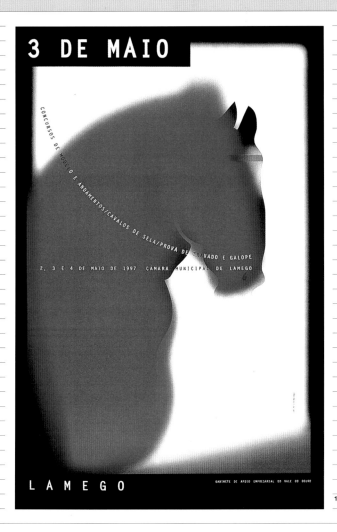

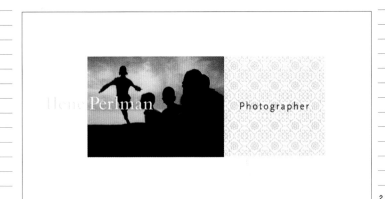

1 海報中小字所形成的動
　線，將視線引導到影像的
　中央，其他編排元素則都
　在影像框的外圍。這張海
　報的成功處在於抓住你的
　視線焦點，並且表達得非
　常清楚。

2 有趣的排列影像和裝飾圖
　騰，而且讓文字的擺放完
　全不會干擾到圖片。

3 精彩的圖像和文字被完美
　的編排在一起，充份展現
　了海報的內涵。

two magpies = 雙喜 double  happiness (*shuāng xǐ*)

**magpie** : The characters for 'magpie', *xǐ què*, literally mean the 'bird of happiness.' A picture of two magpies facing each other stands for 'double happiness,' *shuāng xǐ*, symbolic of conjugal bliss. The call of a magpie foretells the arrival of a guest, good news, or good fortune. A magpie resting on a plum branch conveys the wish 'happiness before one's brow,' *xǐ shàng méi shāo*, as the word for 'plum' and 'brow'

are both pronounced *méi*. Magpies also served to preserve the integrity of a marriage, according to legend. When a husband and wife were to be apart for any reason, they would break a mirror and each take half. If the wife was unfaithful, her half of the mirror turned into a magpie that flew back and informed her husband. Consequently, an image of a magpie is often placed on the back of a mirror.

*preface by Andy Grundberg   introduction by Eduardo Luis Rodriguez*

in$ide HAVANA

darlim

INSTALLATION • SPACE PLANNING

WAREHOUSING • MOVE MANAGEMENT • RECONFIGURATION

# 第二部份
## 編排設計實例與應用

進入實作階段你必須導入編排設計的基本理論，將你的想法和知識融入練習之中。

不管你如何操作，任何一個設計計畫都要進入三個不同的階段：第一階段是概念的成形，必須以客戶的目標和訴求對象為建立基礎；第二階段是設計的思考，畫出想法的細節用來幫你釐清思考的過程；第三階段是設計的製作，設計者和製作團隊之間與設計者和客戶之間的溝通同樣重要。

這一章節的重點著重在第二階段的部分，也就是創造的階段。設計計劃要投入數個不同範疇，每個範疇都有其必要條件，在接下來的內文中將藉由專業實例，來做創造階段的查驗和過程圖解。此外還有一些練習可以提供增進設計能力和評量自我技巧的機會，讓你足以建立自己的知識庫和自信心，進而成為一個創新且富有趣味的設計者。

不論是由他人還是自己提出的概念，一個設計計畫的中心問題都是由你及客戶討論出來的。以當代用語來說，這些問題或可表示成 "WWW.H"，也就是Why、What、When和How much？

# 簡報設計摘要

**Ⓦ 一Why為何而做？**

這一點應該要清楚的表現在你的計畫之中（譬如你是要製造一個市場工具來銷售特定商品或是一則訊息？）並且瞄準目標市場。當這些確定之後，你和客戶將可以決定哪些是需要專攻及設定的過程，並如何進行研究和行銷。

**Ⓦ 一What要做些什麼？**

這將界定你要如何迎向目標，什麼樣的設計製作形式能符合目的？是傳統印刷？還是電腦輸出？或是結合兩者？你的視覺要如何表現？你需要攝影師、插畫家還是文案呢？

**Ⓦ When何時會完成？**

何時交件將決定設計和製作的時程表，在計劃中的三個成員：客戶、設計者和製作團隊，都應該遵守時程表的規定並且準時交付負責的部分。客戶要負責預算的控制、計畫的內容精神和目標，設計者要負責視覺的呈現和提供專業的設計技術，製作團隊要確保計劃可以在期限內完成，並且要達到需要的品質規定，而設計者還必須在兩者之間作協商。

**Ⓦ 一How much有多少預算？**

很少有不受限制的預算，如何分配預算是設計者和製作團隊所要面對的變數，充裕的預算可以讓你自由的探索特殊色或特殊加工製程，像是上霧面、加亮面、壓凸或裁切。但是受限的預算並不代表就會有一個較差的視覺成果，一個有創造力的設計者和強有力的製作團隊可以有效地發揮這些預算來聰明使用色彩和技術。成功的設計亦包含了運用有限資源並發揮它們最大的效果。

在概念成形階段，你和客戶有責任了解每一個人的思考及想法：客戶必須釐清哪一個是他想要的，你必須確認客戶了解你所提出的想法，共同確認的部分則要隨時紀錄下來。

# 練習

- 你被客戶找去討論一個關於兩個電視系統的教育手冊，「The Secret of Sleep」和「In Your Dream」都是關於探討人類未知的睡眠世界。

- 擬出一些你該問的問題，來確認你的設計能達到計畫的目標和方針。
- 現在請同事或朋友扮演客戶，彼此來討論整個計劃，確認所有的問題都得到回答，並且找出你尚未顧及由客戶所提出的任何特殊需求。

- 確實紀錄下整個過程中你的提案被同意的部分，要求客戶複製一份，並確認內容是否一致？
- 以下的範本可以幫助你開始工作。

## Brief for *The Secrets of Sleep* and *In Your Dreams*

**W** – Why is it needed?
1. What is the purpose of the booklet?
2. How closely will it be based on the television series?
3. Will it be published in more than one country?
4. Who is the target audience? Age group? Social group?

**W** – What do we intend to do?
1. How many pages are there?
2. What size is the booklet?
3. Will it be a four-colour print process?
4. Will it be illustrated with photographs and artworks?
5. Will there be a lot of scientific cross-referencing? Should the design allow for footnotes or endnotes?

**W** – When is it needed?
1. Is there an interim date for roughs?
2. Is it expected at the printers on this date?
3. Is there any leeway on the deadline date?

**H** – How much is the budget?
1. Does this include the designer's expenses?
2. Does it include VAT?

## Client's considerations

- Give the designer a general overview of the project: it's an educational booklet aimed at the general public, age group 30-40, no specialised knowledge of dreams. Each booklet will be:

i) 32 pages
ii) full colour throughout
iii) portrait format
iv) A5 format
v) perfect bound

- Discuss the budget. Will you offer a rejection fee? Expenses?
- Discuss payment and contract terms, for example, would the designer like payment in stages or once the job is complete?
- Discuss photographers and illustrators, the designer is responsible for commissioning where necessary. Discuss how many images per double page spread.
- Discuss a schedule. When will the material be ready to send to the designer? How long before the layouts have to be fully finalised and approved?
- If the designer does not meet deadlines, will there be a reduction in the fee?
- Tell the designer what kind of presentation you expect, for example, do you need colour laser proofs or black and white? How many sets of proofs do you need? Who will handle production?

標誌的範圍可以從抽象、具象圖示到純粹使用字形來明確表達出主
題，有些標誌是單純的抽象圖案，譬如**Shell logo**。嚴格地說來，標
誌還是要參考字型，這也是我們這一節要討論的。

# 標誌與文書信箋

## 標誌

一個成功的標誌有三個必要的條件：1.設計要符合自然的架
構，2.標誌應該要是精緻而且獨特的，3.它在單色時的效果
必須和彩色時一樣好，而且必須適合各種不同的大小，小到
名片大到旗幟或廣告招牌。

就某些方面來說，剛開始時以黑白來作標誌的設計會比較
好，但別忘了你可以利用灰色作一個調性的調整，在你滿意
了黑白的設計之後，可以更輕鬆自如地運用彩色。

你要依照你想賦予給標誌的感覺來選擇字體，你必須將它們
修得有整體性，最好的方法是將你設計好的字放在一個你偏
好的現有字體中，再調整它們之間的字距，讓由它們組合所
產生的標誌在視覺上具有平衡效果。你也可以局部修改一些
字母使他們有更高的完成度，但是不要讓它們差得太遠，這
樣會使他們變得難讀而且會破壞整個視覺效果。

請嘗試將文字放在一個簡單的形狀裡，像是方形、圓形或三
角形，用大約2.5cm高的黑色字體在白色的背景上工作，你
可以將圖地元素顛倒看看，也可以讓一部分的字到圖的後
面，此部份讓你學習如何利用圖文間的相對關係進行編排，
還有怎樣以色彩配合。

## 文書信箋

一旦設計好你的標誌，你開始必須將它設定在一些文具用品
上，主要是像印有信頭的信紙、事務用紙和名片上。先從信
頭製作開始，這樣可以做好設定後再利用到其他物品上，你
可以多收集一些其他公司的好設計以作為日後參考之用。

信紙上的印刷文句要盡量接近標準大小，一張信紙通常會摺
疊二次後裝入信封，所以要把它想像成三部分：公司標誌、
公司的名稱和地址及收件人的地址，這些元素要讓它們取得
平衡，你還必須確認沒有重要的物件在摺起來的部位。最好
的解決方法是讓收件人的部分在左邊(事實上這是一般透明
紙窗信封所常用的)，標誌的位置要和放地址的區塊有協調
性，不過最正確的位置，還是要看你希望給予它什麼性質的
整體效果。

你應該先和客戶討論什麼樣的字體適合用在這樣的信頭印
刷，如果還有很多額外的資訊需要被並列在一起(例如：其
他的分店或其他公司成員名單等等…)要確認信紙的尺寸足
以容納得下這些訊息，此外，還要記得留下一定的空間做為
裝訂或打孔之用。

特殊加工製程，像鍍金（將金屬材質套印在影像上）、刻印
（以光面或糙面油墨製作浮雕效果）、壓印（紙面壓凸或壓
凹），都能創造更豐富的印刷效果。

- 製作一系列的設計印刷品，包含標誌的設計，從下面的公司中選擇一家進行你的計劃。
  Smell Sensation 一個連鎖的花卉店，在市場中有許多的競爭者。
  Optimum 製造相機和光學儀器的公司，也生產精密的SLR相機來和Canon和Nikon競爭。

  Giacometti 提供傳統義大利食物的餐廳，希望能夠有現代化的風格。

- 標誌應該要表現出產品、服務或是公司的特質，限制你所用的字型和基本的形狀，不要在視覺上加入太多的變數；在設計上加註你的理論，解說你的想法和評估它的潛力。

- 將標誌套用在信紙、名片和事務用紙上，加上地址，嘗試多種選擇，將它們列印出來，選一個效果最好的。
- 以下的範本可以幫助你開始工作。

Optimum  **Optimum**  **Optimum**  **Optimum**

Optimum  Optimum  Optimum  Optimum

**O**ptimum  **O**ptimum  **O**ptimum  **O**ptimum

# 標誌與文書信箋

## 實例應用

實例1：Teatro Bruto 的設計反映出客戶考慮的劇場特色，Bruto代表了原始和未開化的意思，這個劇場是一個由專業人士作演出的實驗性劇場。橡皮戳章的方式提供了相當程度的力道，來傳遞一個原始和不完美的感覺，而且還有讓標誌數位化的功效。

實例2：Estudio de Opera do Porto為音樂學校在校生和職業工作者之間的一個連繫單位。他的標誌用了一個英文字母"O"來象徵歌者張開的嘴巴，而引號就代表了歌劇中其他的元素，像是歌本和劇本。

1 剛開始要做一些試驗，從許多的字體和顏色中找出最能夠表現橡皮戳章效果者。

2 進一步思考，在這個製程中會用掉多少墨水？因此必須使用精確且俐落的無襯線字體，如此一來，即便省略字體中的某些部份也不會影響到識別。

3 最後出現的是視覺效果很有趣的標誌，正確反映出客戶所要的感覺。

## 專業範例

4 引號穩重且安全的夾住了〝O〞，這可以用來區分其他的標誌，避免和其他的標誌混淆。

5 被壓縮過的無襯線字體看起來像是正在唱歌的嘴巴。

6 這個實例清楚地表現了標誌所要傳達的訊息。

7 最後結果是適度結合了這個標誌，以三個要素的融合，巧妙而簡單地顯示結果。

8 這個例子強調出三個元素：全球性的、數位化的和大膽的Allavide字體，充分反映出這個組織的風格和特點。

9 這個標誌是為一個健康茶飲廠商而設計的，在L的字型中加入茶葉的形狀來表達整個概念。

10 這是一個以簽名方式來設計的畫廊標誌，畫廊名字的部分是用手繪的，再與以打字方式呈現的地址內文組合，表現出藝術家的自由性和創造性。

11 標誌以OVA三個字母拼出來，利用切割的圖片組合出文字的形狀，以影像的質感來突顯背景。

ESTÚDIO DE ÓPERA DO PORTO CASA DA MÚSICA

傳單是一種介於雜誌和報紙之間的印刷品，採用中至大的版面印刷，
通常由公司、俱樂部或文化團體出版，是作為提供新聞、社會運動、
內部活動或組織內一般活動用的訊息平台。

# 傳單

通常，傳單不像報紙或雜誌有時間上的急迫性，你可以有比較充裕的時間來實行一些好的想法和決定設計的樣式。其首要的是預算，也許在內容的部份只能使用單色，頂多在封面也只能用兩種，因為這樣的限制，所以必須使用更多元的字體、尺規和色調以突顯背景。如果可以在封面和封底使用兩個顏色，那你可以用同色調不同濃淡套印圖片，另一個色系則用在頭條或其他主要標題上。

接下來要決定的是格式，必須思考會影響最終樣式的事（例如，傳單需不需要裝進標準信封中，還是要減輕重量以減少郵資？）。所有內文的數量也必須控制，塞入太多的文字會讓讀者在視覺上感到擁擠，要試著給予適度留白。藉著改變圖片大小和不同的標題設計使視覺多樣化。如果內文的部分真的太多，那就以比較小的字體或是比較細或窄的字體來調整。

設計傳單時必須考慮它的內容，也就是要分成哪些部份，比如有專欄、新聞、體育和內部活動等等，了解這些，才能讓你有構思版面編排的明確方向：專欄或許要比較寬的欄位，其他的新聞、體育和內部活動可能就會用較窄的欄位。

一旦你完成了網格欄位的設定，試著用它來分開不同的內文部份，尺規及標題字可以幫助你區隔段落，並且使頁面的視覺成效更清晰明朗。著手於內文編排時，記住下面的原則：
1 你可以藉由改變字體或格式來突顯你要強調的部分（例如從正體字改為斜體字），也可用加框或改變顏色的方式來達

到效果，2整體的樣式要符合組織形象－是現代、時髦的，還是保守、傳統的。

當你已經確定整體樣式和欄位之後，將它設計成樣張以供未來出版使用。公司或許將來想要自己出版，在這些設計案中，你就必須負責監督或諮詢。如果樣張的設計是具有全面考量的，將來在視覺上的問題就可以減到最小。

*appearance*     appearance

appearance
summer issue

appearance
summer issue

- 你被要求製作一個土地開發公司的傳單。它們的業務包含了建築、室內設計和園藝施工，傳單的名稱叫做 Appearance，目標讀者的年齡層在25歲至40歲之間，所以設計必須要有現代感。

- 設計一個封面，刊頭名為'Summer Issue'
- 選一張適合的照片，設計一張整版跨頁內容，要有文章的部分及適合的副標題。
- 設計其他部分，使用一些關於員工離開及加入公司的內文，一些較小的相片和關於近期發展計劃。

- 讓你的同僚了解你的成果，並且討論它的優缺點。
- 以下的範本可以幫助你開始工作。

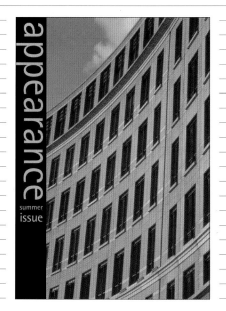

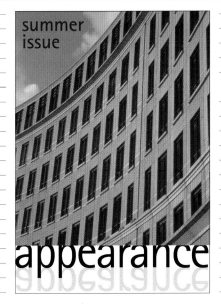

有時候你可以在傳單的設計中做一些大膽的實驗，當然還是必須要符合客戶的需要。設計的樣式必須反映出這是一個怎樣的組織，要考慮到有多少的訊息是他們要傳遞，以及預算是多少。

# 傳單

## 實例應用

這份傳單是FIT(冰島平面設計協會)成員專屬的，它的目的是發佈企業新聞，及有趣、生動的時尚訊息。我們可以看出它的編排和文字排列是顛覆傳統的；單一色調、圖畫式外型、空間運用、以圖形方式處理文字，結合這些設計手法，使得整個編排設計非常生動。

一般在傳單上只使用文字印刷是很冒險的，但是這個例子卻非常成功，因為它充份反映出這個組織的目的。

1 注意標題文字的運用方法。

2 格式的安排跳脫傳統而且非常大膽，但它十分有效地平衡並且突顯刊頭。

3 文字在這裡是一個材質的表現，而不單單是訊息而已。

4 以簡單有效的設計來表現專業內涵的傳單。

5 以色塊的運用改變樣式，及一些線條來變化文字的表現，兩者的結合使傳單更為生動。

6 這個例子示範了有效的空間使用，沒有浪費多餘的空間在刊頭部分，將刊頭垂直排列並分成左右二邊，也具有分開內文的功能。

專業範例

4

5

6

小冊子包含了所有跟銷售資料以及關鍵訊息相關的種類，它的範圍可以從藝術展覽的介紹到生活健康的資訊。因為有著這樣多的出版內容，所以就可以表現很多不同的視覺設計，因此，設計師要盡量去接觸這類案子，僅管你還不清楚花費。

# 小冊子

和設計傳單一樣，第一步是要了解內容以確認網格的安排，如果手冊主要是做為銷售的工具，那就必須要強調圖像的資訊(照片和圖解)，而說明的文字則具有輔助功能，這些文字可能是由一些設計過的號碼及價錢來組成，亦或者是一些關於物件細部的描述。如果文字為唯一的設計元素，那麼一個具有彈性的小單位網格會比較適合，這樣可以讓你有多種不同的欄位分配，來包含大小多變的視覺元素和小型文字方塊。至於寬一點的欄位則讓你可以應付更多的細部說明文字。

另外有種小冊子設計，其文字和圖片所占比例大抵相同，因此網格的安排可以不用太複雜。照片需要說明，照片說明放在較窄區間會有較佳的效果，所以在網格配置時，需予以較小的單位數。

等你決定了網格的設計而且已經從客戶那裡拿到了所有內容素材之後，試做幾種整版跨頁的編排，將內文、標題、照片和圖解做一些安排，你可以依照你想嘗試的做法很快地作一些調整，在第一次給客戶看時可以發表多種版本，這樣在開始討論時會有較充份的比較。

假如小冊子的主要功能是要提供資訊，那麼就會需要使用更多文字。試著去改變整個版面的流暢度，雖然要全然以文字來做這樣的改變是困難的，你可以避免在字級上變化太大，而應該在你要表現的視覺影像上確認其對比性，你可以藉著大小(大的圖片搭配小的圖片，或是細部解圖)或色彩

(黑白圖片搭配彩色圖片或是彩色圖片配上用同色調不同套印的圖片)來達到目的，照片的處理則可以使用裁切技巧(參考第78-79頁)。要有能力將版面安排得有趣又不誇張，才是一個好的手冊設計之道。

- 設計三份黑白整版跨頁的手冊，並且要附加照片，三份手冊至少要使用8張照片。
- 幫每一張照片寫一個適合的標題。
- 然後設計封面，並且加上適合的標題和圖像。
- 讓你的同儕了解你的實驗成果，並且討論它的優缺點。
- 以下的範本可以幫助你開始工作。

# 小冊子

## 實例應用

此跨頁的版面構成非常吸引人，在兩個頁面間有著相當大的對比，一邊是單純的文字，另一邊則是由圖像佔據，大量的留白讓讀者的眼光可以很自然地在不同訊息間瀏覽。

內文以極具想像力的方式編排，用不同的分配、大小及設定形式，讓最終成果具吸引力但又不至於太過複雜。

1 一般內文和副標題都會以簡單且易於了解的方式來傳達訊息，這樣可以和複雜的圖像取得一個平衡，並且使整個版面不會有做過頭的感覺。

2 一個有趣使用內文及圖像的方法，重複使用一些簡短內文，讓放在 "In" 文件盒裡的文字量少於放在 "Out" 文件盒裡的，藉以強調出效能和產能的銷售訊息。

3 碼錶的一部分被推到右邊那頁，這樣的表現有兩個目的：第一、這一部份表現了〝效率〞這個字要放在哪個位置才標準(如何在碼錶上找到適當的位置，它本身是一個時鐘，也算是一種標準)。第二、挪開的這塊留白空間可以給圖片填滿的空間一個凸顯的特色，相反地也可以填補右邊那頁空白為底的部份空間。

# 專業範例

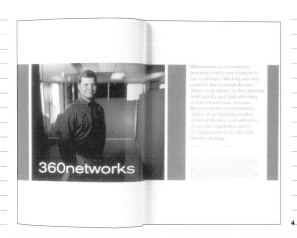

5

4

6

**Burials,
buckets
and
beyond...**

7

4 設計的有趣處在頂部和底部有很寬的留
　白，以及左右兩邊垂直的設計，將內文
　從照片中區隔出來。人物看起來好像是
　在照片的正中央，雖然這是圖片延伸至
　右頁所產生的錯覺。

5 這個手冊的封面，在結合照片和圖像上
　有非常好的平衡。

6 因為角度的關係，你會很快注意到這張
　都是文字的底圖，圖片和文字結合得很
　好，使整個封面有一種三度空間的感
　覺，並且取得良好的協調性。

7 這份整版跨頁給人一種深邃感，它是利
　用幾個很暗的顏色來塑造這樣的感覺，
　主標題則以紅色自版面中凸顯出來。

在諸類平面設計中，可能沒有一種要比雜誌來得多樣化了。雜誌的範圍可以從嚴肅的、資訊的、輕鬆的到諷刺的，而且雜誌的封面可以有各種不同的表現空間。

# 雜誌

跟製作傳單和小冊子一樣，在著手設計雜誌之前，你需要了解雜誌的目標讀者及目的，不同類型的雜誌需要不同的視覺處理，內容將決定你所設計的網格：有些以文字為主的雜誌需要比較緊密的結構，若是以圖像為重點的雜誌就可以安排得比較自由。

客戶提供的原稿對雜誌的成功與否是很重要的，客戶所提供的文稿或是圖稿都會影響整個內容的走向。雜誌的走向和感覺最終還是要取決於客戶的需求，嚴肅的、理論性的雜誌一般是以內文為導向，你就應該集中精神在處理字體的大小和字型，不要讓文字變得太過鬆散，用有襯線的字體可以給這樣的雜誌一種嚴肅的、傳統的感覺，無襯線字體用作標題，則有比較現代的感覺。

一般讀者傾向於從雜誌中涉獵所需內容，而不是從頭到尾一頁一頁閱讀，所以豐富的視覺效果是十分重要的，試著創造平面設計的"步法"－像是讓前個版面是安靜的、富有文字的，而下一個版面則是有著豐富視覺表現。去看看市面上的各種雜誌，如何用各種不同的表現來滿足個別需要；好的設計案可以示範如何生動地結合文字與圖像。

# 練習

- 你被邀請加入一本藝術雜誌的重新設計工作，你可以選擇的主標名稱如下：Art Now、Contemporary Art、Articulate 及 Artworks，主要的特色在於 Alec Hunting 這位藝術家。

- 為你所選擇的主標名稱做刊頭設計。
- 然後再以下面的句子做封面標題的設計 Hunting at the Central Gallery pop art or minimalism？Ends May 31

- 設計一個包含有五到六個欄位的網格，然後挑選三種可以分別用在內文、標題及引用語的字型。
- 以 Alec Hunting 為主題(或是其他你自己想做的主題)，至少設計兩個整版跨頁，請專注於調整文章的流暢度，在版面上交互調整圖片和文字的比例。
- 以下的範本可以幫助你開始工作。

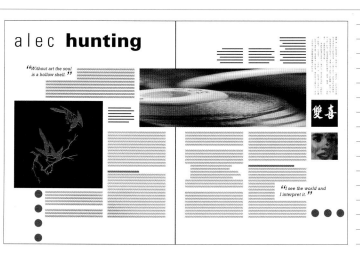

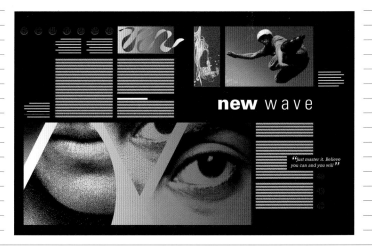

Sight and Sound是1930年代發行的一本嚴肅之電影雜誌。電影工業一直是在創造新的風潮及型態，所有以電影為主題的雜誌都必須要能反映這一點。

# 雜誌

## 實例應用

Sight and Sound是由英國電影學會出版的雜誌，不斷更新他們的型態藉以創新設計，是這樣一個長期且成功經營的雜誌之最大優質處。他們最近重新設計的部份就是要推廣一些有趣的劇情片。

1 這種現代感的無襯線字體叫做Bruener，中間的 "&" 符號被特別修粗過，使其重量感可以跟其他字配合。

2 主標的部分通常是使用無襯線字體，能夠給雜誌一種現代、時髦的感覺。在易讀性不被放棄的原則下，內文部份則往往使用有襯線字體。

3 雜誌設計要成功，視覺效果的轉換和色彩的安排是最重要的，這亦使每項元素得以妥善配置並形成有效的版面結構。這份雜誌為了設法包含所有影片的生產細節，所以它以很小的字體以及兩個靠得很近的網格來編排，這是非常有效使用空間的方法。

4 這個整版跨頁展現了相當有趣的視覺表現，包括照片大小的對比、色彩的運用及很有彈性的網格編排，這些都是很好的雜誌設計範例。

5 這些標題文字做了一個多樣組合的良

# Sight&Sound

**The Monthly Film Magazine/November 2002/£3.25**　　1

**Interview**

# Premium Bond

**Edward Lawrenson: Were you surprised when you got the call to do the movie?**
Lee Tamahori: I was, because I thought I'd have been the last person they'd ask. I was doing another hard-edged, visceral movie in LA which had just fallen apart. My agent phoned and I didn't hesitate. First, I wanted to do a movie my kids could watch because　　2

# Two Men Went to War

**United Kingdom 2002**

| | |
|---|---|
| **Director** | **Music Supervisor** |
| John Henderson | Robin Morrison |
| **Producers** | **Music Producer** |
| Ira Trattner | Michael Paert |
| Pat Harding | **Production Co-ordinator** |
| **Screenplay** | Claire Griffin |
| Richard Everett | **Executive Producer** |
| Christopher Villiers | Tony Prior |
| **Director of Photography** | Fireworks Music Ltd |
| John Ignatius | **Music Editor** |
| **Editor** | Michael Paert |
| David Yardley | **Music Recordist/Mixer** |
| **Production Designers** | Gerry O'Riordan |
| Sophie Becher | **Soundtrack** |
| Steve Carter | "Run, Rabbit,Run", "(We're |
| **Music/Music Conductor** | Gonna Hang Out) The |
| Richard Harvey | Washing on the Siegfried |
| | Line" – Flanagan and |
| ©Two Men Went to War | Allen; "Turn Your Money |
| Partnership | in Your Pocket" – Jimmy　　3 |

好示範，旁邊的粗線提供了畫面重量上的平衡感。

6 在欄位中保留空間插入引句，不但配合內文而且有強調的效果，對比字體 (無襯線粗體字和有襯線字體)也是做為標題設計的良好示範。

"Had we cruelly trampled the purveyors of documentary truth in our rush to the top?"

Nick James on Stephen Frears' London immigrant drama

## Subterranean homesick blues

---

Theroux and I never hug, though Broomfield recently became a neo-hugger (see the final "you make a lovely stew" scene in *Biggie and Tupac*).

At his very best, in *Roger & Me* and now *Bowling for Columbine*, Moore is quite brilliant at creating – using archive material and savage comedy – a political panorama that startlingly interweaves the macro with the micro. One of the most powerful and convincing moments in *Bowling for Columbine* is his drawing of a parallel between the US selling weaponry to Eric Harris and Dylan Klebold, the teenagers who shot up Columbine High on 20 April 1999, and the US providing training and finance to Osama Bin Laden during Russia's invasion of Afghanistan. He even manages to get a representative of arms manufacturer Lockheed Martin to say, "What ▶

"I want the account where I get a free gun, says Moore. The bank manager calmly agrees"

6

---

# Reviews

### The main attraction

Ryan Gilbey wonders if the politics of 'Changing Lanes' are shift stick or unthinkingly automatic

## Street legal

Samuel L. Jackson has not yet provided compelling evidence that he can play much besides funky hipsters (*Pulp Fiction*, *The Long Kiss Goodnight*) or righteous avengers (*A Time to Kill*), but the conscientious thriller *Changing Lanes* hints there are fresh ambiguities to be mined in the latter category. Here Jackson plays Doyle Gipson, whose abstinence from alcohol does little to temper his temper after a collision on New York's FDR Drive with hotshot attorney Gavin Banek (Ben Affleck). Doyle tries to act honourably. It is he who refuses Gavin's offer of a blank cheque, and later he will also make an attempt to return to Gavin the important legal

both instances Doyle's good nature goes unappreciated. In the first Gavin speeds off to court, leaving Doyle – who also has a court appointment, to stop his ex-wife and young sons from moving state – stranded on the freeway. In the second Doyle's altruism comes too late to prevent Gavin's visit to Mr Finch, a computer hacker who renders Doyle bankrupt with the touch of a button.

The screenplay, by Michael Tolkin (*The Player*, *Deep Cover*) and debutant Chap Taylor, sometimes seems poised to commit the ultimate heresy of making a main character in a Hollywood movie unsympathetic: in one scene Doyle

5

就某些方面來說，廣告和其他設計類型不同，它必須用「強迫推銷」
的方式來增加產品的銷量，或是說服客戶來購買商品，這和部份基本
編排設計原理倒是相通的。

# 平面廣告

整體說來，平面廣告是依賴很強的概念及很好的藝術技術
結合而成的，不論是遣辭用句還是視覺傳達都必須要使讀
者相信這是符合他們需要的產品。一個好的文案是不可或
缺的，在一個方案中它的文字必須要讓讀者留下印象，而
扮演設計師角色者，則應該要釐清，這樣的訊息適合什麼樣
的編排形式。

如果這份廣告是用來促銷及提供情報，你可以突顯最具影
響力的部份，在內文已經寫好並確定重點之後，再以視覺
概念的方法來反映這篇文字內容。

我們的文化經驗告訴我們，廣告在視覺上就是要與眾不
同，所以在平面廣告的編排構成和文字運用上可以做更大
膽的嘗試。活用一些意象比喻來結合圖案，會讓廣告更容易
受人注意，如果在設計上只能單單依賴文字而沒有圖像，
你也可以利用反轉、重疊或是改變方向等方式來改變文字
的視覺效果。多做實驗可以幫助你解決沒有圖像的問題，
在文字的使用上，你也可以嘗試一些幽默的手法，但是還
是要有一些限制，不要被誤以為這是「古怪的」。不過，平
面廣告仍然是最能容許你做任何實驗的編排設計項目。

# 練習

- 設計一份叫做〝Art Works In Mental Health〞的廣告。
- 設計一個跨頁的節目導覽。
- 目標對象的年齡在25－35歲。

- 廣告要設計成適合風景照規格的大小樣式。
- 在廣告的下方一定要加上活動訊息，並且至少要自行設計兩個適用的圖案。
- 使用四種顏色。

- 嘗試各種圖案、形狀、字型及編排風格。
- 以下的範本可以幫助你開始工作。

# ART WORKS IN MENTAL HEALTH

**Art Works in Mental Health is an exciting new exhibition of creative work by people who have been affected by mental illness.**

The exhibition is designed to enhance our understanding of mental health issues.

**Entry is free**—*the only thing you need to bring is an open mind.*

**www.artworksinmentalhealth.com**

**London** July 3–13  *10am–5pm.* **Riverside Galleries** Chelsea.
   Open daily
**Paris** July 17–27  *8am–5pm.* **Galerie d'Art** Montparnasse.
   Open daily
**Berlin** July 31–August 10  *9am–7pm.* **Galerie Schneider** Berlin.
   Open daily
**New York** August 18–28  *9am–5pm.* **ArtWorks**, Greenwich Village.
   Open daily

# 平面廣告

## 實例應用

這個設計的特徵，在於整個系列的廣告都以同樣的編排版型、顯眼的 "garbs" 標誌及敘述，作結合，讓此系列的廣告很容易被識別並且令人難忘。

此系列廣告還有一個有趣的特徵，即利用了很多一般人容易記得的發音或意義類似的詞句來敘述商品，例如在關於袋子的部分就以 "stuff" 代替 "staff"。

照片的利用雖然不多，但卻展示了多種表現。變換使用大、小寫字母、不同字型和標點符號都增加了畫面的衝擊力。字體重量對應著商品予人的感覺：中粗體的字用在靴子和袋子的地方，重粗體的字用在毛衣，最粗體的字則用在大衣外套。

1 主標題字體的大小選得很好，給了整體畫面極佳的平衡感，用量尺的方式將不同大小和形式的靴子，在視覺上巧妙地連結起來。

2-3 在標籤上寫下設計者的名字，加強了造形特徵，在中央圖案下方的文字則儘可能地和圖案形成對稱，使該廣告顯得更勻稱。

4 這個影像做了一個三度空間的表現，但是仍然可以很簡單地被辨別，主要是藉由這一疊衣服從上到下明暗交錯分明之故。

5 在主標題中將 & 符號用與其他字不同的顏色來表現，可以讓這麼多的字排在同一線上而又可一一被分辨出來，並且讓主標題的長度正好和圖案的左右二邊對齊。

**Richard Hollis**在**Graphic Design**中說到：描述海報發展的簡史就像是解釋平面設計的本質，通常在說到平面設計的藝術形式時，海報設計是流傳最久遠的形式之一，而且也是文化中最不可或缺的部分。

練習

# 海報設計

- 設計一個推廣哲學研究的海報，是Aristotelian Society這個組織的系列活動之一。
- 海報將會展示在大學學院及圖書館，客戶希望引用哲學家的名言作為該系列的特色，因此重點在於引文必須要很容易閱讀，同時要將引文的涵義融入於你的設計之中。

在19世紀，早期的傳單式海報顯示了職業工會的努力與苦鬥，之後圖像及字體的運用遍及了歐洲和美國，我們可以從歷史的角度看出當時海報設計在技術上的進步。

一個理想的海報設計需要有兩種功能，第一、它必須能夠引起別人的注意，第二、它需要能夠傳達訊息。好的海報必須要達到這樣的標準，同時要能創造對味的版型且善用色彩。海報製作是個大工程，也因此它讓你有機會可以大膽嚐試將文字視為圖像的運作。

海報設計最重要的功能，就是必須能立即傳達主要訊息。因為它通常只會給人很短暫的一瞥(想像一下觀看路邊海報的情形)。如果是書封面你可以使用較小的字體，因為我們通常以15-20公分的距離來閱讀，但在設計海報時，太小的字體是完全不被接受的，基於同樣的理由，不要在設計中加入太多的元素：讓你要表達的重點，藉由設計版型和色彩迅速而強烈地表達出來。回想你見過最有效的海報，單一而強烈的元素會比許多元素的組合好得許多。讀者喜歡清楚而且能夠容易消化訊息的海報。

並非所有的設計，都會使用機器製版印刷，手工絹印也能有不錯的表現，它可以充份表現特殊印刷色彩的質感，例如使用有光澤的漆料，在暗色紙面上印出明亮的顏色。但是當你需要印製上千張的海報時，就需要用機器製版印刷，並藉由四色分色印刷，製作色彩更臻精確的成品。

"Cogito ergo sum"

"Cogito ergo sum"

"Cogito ergo sum"

"Cogito ergo sum"

"Cogito ergo sum"

"Cogito ergo sum"

"Cogito ergo sum"

"Cogito ergo sum"

"Cogito ergo sum"
(I think, therefore I am)

RENÉ DESCARTES 1596–1650

"Cogito ergo sum"
(I think, therefore I am)

RENÉ DESCARTES 1596–1650

- 你要控制的編排要素有：字體的決定、內文的安排及架構、色彩的使用，並且確定整體的風格。
- 從下面的引文中選出一個段落文章：

"No man's knowledgecan go beyond his experience" John Locke 1632-1704

"Cogito ergo sum(I thinnk therefore I am) Rene escartes 1596-1650

"The world is everything , that is the case" Ludwig Wittgenstein 1889-1951

"The heart of manis made to reconcile the most glaring congradictions" David Hume 1711-1776

"Is that which is holy loved by the gods because it is holy , or is it holy because it is loved by the gods？" Plato 427-347BC

- 接下來加入其他內文：

The Aristotelisn Society lecture series begins with(哲學家的姓名由你的選擇而定 )on(日期 )For further details,contact the Secretary at the (大學的名稱)。

- 將你完成的設計固定在牆上，往後退到適當的距離，從這個觀點來確認設計是無誤的，要求自己只要內文有一點不易辨認，就須做必要的調整。
- 以下的範本可以幫助你開始工作。

一個成功的海報不能夠以文字和圖樣來傳達太多的訊息，過多的設計反而會讓它混淆，必須要藉著形式和色彩的組合讓它看起來更具吸引力，總之，記住海報是用來傳遞訊息的，最好一眼就能被瞥見。

# 海報設計

## 實例應用

這張海報要傳達的訊息非常清楚，落下水滴的圖像直接顯示出主題，字體選用無可挑剔，而且不會與圖像衝突。

1 簡單、不浮華的圖文編排，在不互相干擾的情形下，讓元素各司其職。

2 使用無襯線粗體字加強了文字的強度，用較小的字級使它不會和圖像衝突且適度融入背景。落下的水滴被置於中央，則強調了中心點的重要。

3-5 變換背景的顏色，清楚地表現出色彩在設計上可以有多驚人的影響力。

6 海報使用了非常動人的色彩組合，它甚至不需要文字，圖像便直接表達了訊息。這是非常有吸引力、簡單而且令人難忘的設計。

7 柔焦的影像給這張海報一種抽象的感覺，中央的文字雖然不大卻可以讓人一眼就能辨別。

8 眼睛的部分是整張海報唯一沒有被"壁畫式"文字蓋住的部分，以此方式來吸引觀眾注意。文字的意義主要是在意象方面而非傳達資訊。

9-10 這兩張海報有著相同的成功準則，明亮色彩、單純影像及最小的文字。

6

7

8

9

10

包裝設計者是個憑著本能學習包裝知識與技術的專家，在這裡我們將
著重在探討包裝的 "外觀" 設計。

# 包裝設計與商標

有些包裝只是純粹裝飾用的，例如藥品包裝，只需傳達重要訊息即可。包裝設計的重點有兩個：包裝上的訊息必須印刷清楚；迅速確實地傳遞文字訊息。字首大寫的小寫字體會比全部是大寫字體更容易被讀取。左起的文章較易編排與校對，盡量迴避從右方開始編排，且不要大量使用斜體、裝飾性字型或顛倒類型的文字。試著不要中斷字組。用於警告性或其他重要文字時，在顏色運用上應儘量採取較大對比。善用顏色讓警示性質的內文易於被搜尋，特別是罹患色盲或視力損傷的讀者。

裝飾性的包裝能給你更多想像空間，尤其是在顏色及插圖的使用上，你可以用複製的方式做不同型態的實驗進行編排實，非對稱的設計有助於讓讀者自行去分類。

在某些包裝設計中，你必須想像編排設計會如何展現在不同的平面上，例如，你要決定是否讓所有的圖文都遍及封面和側邊；包裝內容會決定你使用的顏色範圍；產品本身的名稱，往往能提示你應該選擇何種顏色。

包裝的製程中，還必須慮及能否給予設計更大的空間。玻璃紙、彩色薄紗、出血和其他印刷技術，諸如分層、打亮、打凸或打凹，這些特殊選項都是需要被思考進去的。

決定所有包裝設計之前， 可以先試試立體的實物模型，讓你和客戶比較容易想像整個設計將會如何作呈現。

## 練習

- 設計'"Formula Perfume" 或 "Ryder's Aromatherapy Candles"產品的外包裝和商標。
- 對新世紀的消費者而言,包裝應該更具現代化和流行趣味,而非保守的設計。
- 就價格方面,屬於中等價位。

- 在你考慮包裝的大小和形狀時,記得它必須適合產品。
- 使用四種顏色。
- 在你決定最終版本之前,多做幾個模擬的作品。

- 從生產和運送方面,確定你的設計可以被實踐。
- 以下的範本可以幫助你開始工作。

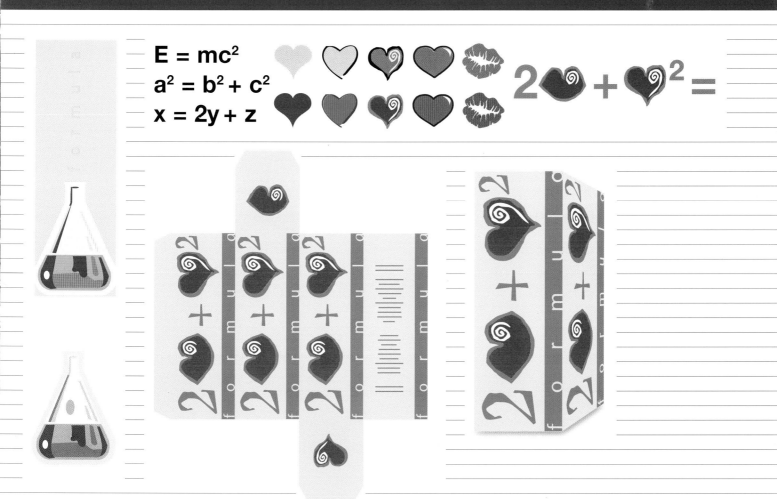

# 包裝設計與商標

## 實例應用

此CD個案在傳達訊息上是個好案例，攝影師透過展覽、出版和表演節目來呈現文化的多面貌，在包裝上表現多層次的感覺。不論透明化學材質的CD外盒或半透明紙張，印刷技術都使得設計品質有很大的提昇。

1 大膽用色並使名字突出，使用無襯線字體且可以反白。

2 全部現代感的呈現令人感到興奮。

3 簡潔整齊的線條與色彩運用，使袋子展現精緻的感覺。

4 利用垂直和水平混合的文字編排和多元素的結合，構成勻稱的包裝設計，垂直的"juice"商標與中間的插圖和水平文字互補，因而更生協調。

5 時髦的火柴盒是清楚描述內容的完美例子。

6 一個熱鬧、流行且有趣的設計；形狀和顏色上深具張力，充份反映這個商品的特質－聲音的爆發力。

7 這是外包裝與商標成功組合的CD設計案例。白色背景上的許多小圖片，讓整體包裝呈現了平靜祥和的氣氛。

1

2

# 專業範例

3

4

5

6

7

網際網路是許多企業的重心，所以網頁應該是特殊、具有吸引力、顯著和有趣的。它應該讓訪問者可以輕鬆且清楚地瀏覽。

# 網頁設計

當你作出任何設計決定前，必須先考慮到網址將來擴展的可能性。你必須建立檔名架構；隨著網址的成長，如果檔名組織得不好，將會很難清楚記錄一切，例如：在資料夾內必須合理的分享檔案名稱和相關資源；如果這個文件稱為home.htm，那麼flash檔應該稱為home.swf。

請記得你的訪問者將不只瀏覽這個位址，而是會在不同的點之間來回參觀。他們也許會從其他網站連結到你的網站，而不完全是經由你的首頁。因此你需要簡單的瀏覽系統來呈現每一頁網頁內容。公司的商標與名稱通常會擺放在左上角，或者每個網頁的最上頭。

瀏覽時的閱讀順序，通常在左上角是起始位置，如果螢幕小於網頁，擺在右下角的元件將會看不見，必需滑動網頁滾軸才能看得見。

連結使頁與頁之間清楚連接。網頁裡可連結的部份通常以較明亮的顏色來顯示，而任何曾經被連結過的部份，將呈現較暗沉的顏色。通常，可連結處會被特別強調，雖然並沒有絕對必要。另外，你不必特別強調普通的內文，那會使它看起來像連結，你可以透過底線、顏色的使用，或者利用加粗字寬的方式來強調文字。

## 頁面大小
當不能控制頁面大小時（水平捲軸跟垂直捲軸都是無限大），編排佈局應該儘可能適應於任何電腦螢幕大小。一般是使用沒有邊境(或看不見的)的格式。

## 網頁類型
記住網頁是一個活生生的媒體，訪問者是以跳躍方式閱讀而非直線式像閱讀書本一樣。內文的呈現通常會比印刷形式來得更短、更簡明，因為讀者並不喜歡上下移動捲軸或者使勁用眼力。你選擇的字體應該套用在你所有的設計上，甚至包括核心網路字體（例如微軟瀏覽器）。

## 螢幕顏色
雖然印刷物的顏色通常使用 CMYK（參見第 62 頁），但是電腦螢幕顏色顯示則依照RGB（藉由混合各種數量的紅、綠、藍色，來產生其他顏色），從256色到超過一百萬個顏色的顯示，取決於用戶的螢幕解析度。由於你無法決定用戶端的螢幕解析度，所以最好使自己侷限於 256 色。256色中，不論在Mac或PC僅有 216個顏色是可用的。這216色被稱作網路安全顏色，在所有現代設計中皆可被應用，並且可以被輸出為GIF檔(graphics interchange format)。就照片而言，漸層和其他連續的聲音圖像，需要使用JPEG格式存檔(joint photographic expert group)以避免出現斷層的帶狀物。

- 你被委任設計一個網路花商的網站" Beautiful Bouquets "。
- 在紙上依照你概略的想法畫出3個網頁,包含:首頁和兩個連結頁。

- 用Photoshop或者類似的軟體設計網頁。你要在25x25公分的範圍中設計。
- 使用照片,圖像和說明文字。
- 首頁應該至少有五個連結。確信使用者能夠在你設計的網頁之間清楚地瀏覽。
- 使用的文字字樣和顏色應該反映出企業

的特質。
- 在左上方放置公司商標。
- 下面的概念將幫助你開始作業。

## 頁面佈局

你應該避免瀏覽欄位,因為瀏覽者勢必會連續不斷地上下滾動捲軸。你可以將與主題相關的內文,製作成連結,這是節省網頁空間的有效方法。

## 轉檔

在你完成設計後必須將檔案轉存成HTML格式,你可以使用Macromedia fireworks 或 Adobe Image Ready 等軟體工具,這些桯式將使你的編排設計轉變成瀏覽器。試著避免使用太大的檔案,讓每頁大小不超過50k。你的網站應該適用於目前常用的瀏覽器和平臺,建議你,不要為了滿足自己而下載太特別的瀏覽器。

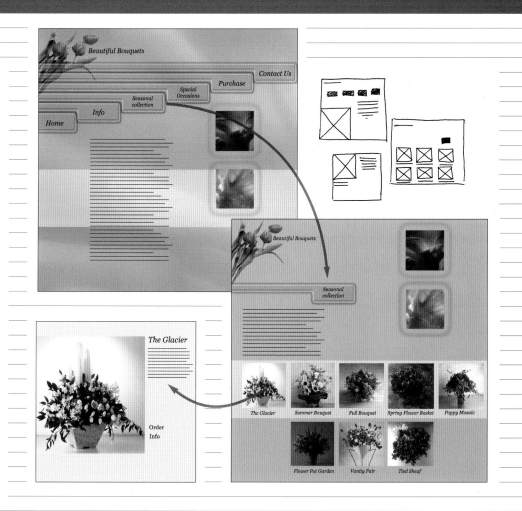

如果參觀者能在瀏覽上沒有困難，就是成功的網頁設計，
這也是為什麼要保留某些元素在類似的地方和保留相同的
風格。

# 網頁設計

## 實例應用

此次的客戶－攝影公司－想要一個乾淨且有流行風格的網站。因此呈
現公司的設計時，儘量減少文字的使用，並強調圖片，裁切圖像是為
了製造不同形式的視覺焦點。網頁中的動畫，則同時具備自由與壓迫
感，帶給網站頑皮且有創造力的感覺。

1 客戶想用性感的開始產生神祕的興奮感。

2 為了製造視覺衝擊的效果，在其中插入模糊的影像結構。

3 在中央位置取得平衡的設計，參觀者能將滑鼠拖曳到螢幕上的任何選
　項。黑色背景的覆蓋能清楚突顯選項。

4 讓選項像個鐘擺一樣擺動，直到它的靜止

5 這一幕完全呈現大圖像的魄力，也顯示了細密的計畫。將選項放置在螢
　幕左側，完全不干擾攝影作品的目光焦點。在照片左邊的兩個方格分別
　是能改變照片順序的按鈕"下一張"和"上一張"。左邊最底下的角落則是離
　開網頁的按紐。

5

8

6

9

7

6 按"往前"或"往後"，可瀏覽前後頁的圖片

7 轉換圖片時，在"向前"及"向後"中間顯示各一半的照片，中間呈現了半透明感。

8 客戶能夠輸入密碼保護，驅動網址個人化和資料庫，播放結束時，亦可留下附註文字的對話框。

9 當訪問者點選螢幕上的選單時，可以使訪問者留下他們的聯繫方式。有更多的用戶偏好Flash表格大於HTML表格，因為可以隨時提交表格和留下證明。

# 網頁設計

## 專業範例

1　這個首頁清楚地展示出浴室零售商的特色。中央的圖像設計深具現代感。商標出現在每頁的左上方，連結則在商標的下面，讓人很容易從其相關位置去連接它頁面。

2-3　每一頁的訊息都依循相同的設計方法編排。

4-7　獸醫研究進展的網頁使用Flash的外掛程式。這是有趣、生動、且令人鼓舞的網頁。從左邊的彎曲連結動線到圓形文字盒，圓圈形成了設計的基礎，讓你能在右邊的紅色和白色圓圈滾軸中自由徘徊。儘管圓形圖像和複雜結構不斷地在移動，這個網頁還是非常容易瀏覽的。

8-10　這個網頁是為了讓人容易接近花、植物和樹的照片圖書館。背景顏色柔和且有平靜的感覺—完美表現出自然的攝影的自然特色。

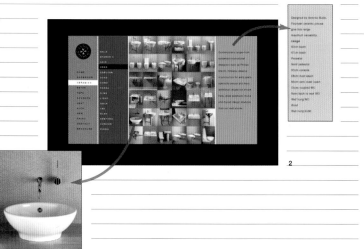

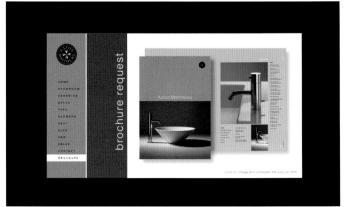

4

5

8

The Use of Plasma Cardiac Troponin I (cTnI),
Cardiac Troponin T (cTnT) and Atrial
Natriuretic Peptide (ANP) as Biochemical
Markers of Cardiac Injury Associated with
Doxorubicin Chemotherapy

by Drs. Craig Clifford, Karin Sorenson, Marc Ernaro, et al.

6

9

7

10

在過去幾年裡，設計師的角色定位有了相當大的改變。電腦的出現，大量取代了精密的手工製作，電腦印刷輸出的極佳品質建構出卓越的視覺水準，也讓人們變成更仰賴於視覺觀看。

# 向客戶提案

顯然的，傳統技巧在設計提案中仍扮演著重要的角色。多餘背景的剪裁、整體版面的配置以及妥善運用各種元素，造就整體設計的精采表現。就心理層面來看，高水準的提案具有決定性。因為第一印象的好壞也受此影響。

做提案時，其中一個最重要的問題，就是客戶所預期的水平在哪裡。如果客戶有視覺上的要求，以黑白輸出稿做"初步"提案就很必要。無論你決定以何種方式呈現，必須先和客戶討論：時間與費用、需要看幾種提案，以及你預算中的全程開銷成本。另外，如果提案重點只是著重在適合閱讀的商標設計，你還必須考慮是否有必要鉅細靡遺地說明所有內頁中的每一頁？

在呈現你的設計提案時，建議回歸到最初的概念，簡報符合原始目的的設計決定。身為一名設計師，你必須培養良好的溝通技巧，以利推銷你的作品。你也要很有雅量地接納負面評價，當然犯錯是難免的，如何回應錯誤與指責才是重點。如果客戶看到你盡力地解決問題，一切困難便能自然迎刃而解。

最後，在提案前先花二至三倍的時間確定每個環節都已詳加分類並位於正確的部份。

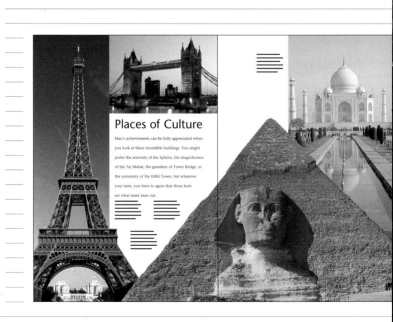

## Places of Culture

Man's achievements can be fully appreciated when you look at these incredible buildings. You might prefer the serenity of the Sphinx, the magnificence of the Taj Mahal, the grandeur of Tower Bridge, or the symmetry of the Eiffel Tower, but whatever your taste, you have to agree that these feats are what mark man out.

- 將你完成的小冊子或雜誌練習，用三個階段拼貼完成。
- 首先，回歸基礎並在一張紙上畫出最初的構想。

- 粗略拼湊成一個草樣。這是沒有影像與文字的基本版型結構。
- 使用全彩，將所有物件天衣無縫地整合在一起。

- 將你的成品展示在朋友或同事前，說明你所經歷的不同階段並徵求意見。
- 這些建議將有助於你開始工作。

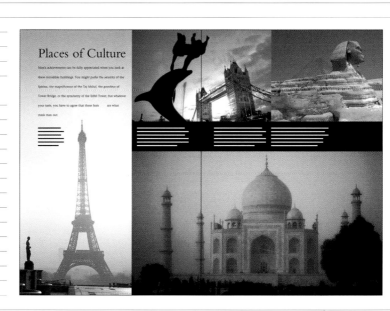

# 索引

# 參考圖片原作者索引

t=top(上), b=bottom(下), c=center(中), l=left(左), r=right(右)
P.1 bl The McCulley Group, br Studio International; P.2 t Chronicle Books,
b The McCulley Group; P.3 l R2 (Ramalho & Rebelo Design); P.6 tl Chronicle Books,
cl The McCulley Group; bl Becker Design; P.7 t Einar Gylfason, t and cr The McCulley Group, bl Chronicle Books, br
The Riordon Design Group Inc; P.10 cl Chronicle Books, bc Studio International; P.11 lc and c The McCulley Group;
P.15 tl Terrapin Graphics,
tr Yee Design; P.17 t Falco Hannemann, l Terrapin Graphics, cr Noah Scalin/ALR Design, br Eugenie Dodd
Tyographics; P.21 tl Dotzero Design; tr Gee + Chung Design, bl Hornall Anderson, br Philip Fass; P.25 tl Chronicle
Books, tr Fabrice Praeger;
P.29 tl The Riordon Design Group Inc, tr Kurt Dornig, cl R2 (Ramalho & Rebelo Design), bl Chronicle Books, br Falco
Hannemann; P.33 t, c, br Chronicle Books;
P.36 tr Erich Brechbuehl; P.37 tl Kurt Dornig, tr The Riordon Design Group Inc,
bl and r LOWERCASE Inc.; P.41 l Gee + Chung Design, r João Machado; P.45 tl
and r Philip Fass; P.53 l Gee + Chung Design, r Grundy & Northedge; P. 57 t and
bl Chronicle Books, br Studio International ; P.61 tl, bl and r R2 (Ramalho & Rebelo Design), tr Fabrice Praeger; P.65
tr Philip Fass, bl and c The McCulley Group,
br Yee Design; P.71 r Gee + Chung Design; P.73 tr Noah Scalin, ALRdesign,
tl LOWERCASE Inc, br Studio International, bl The McCulley Group; P.77 tr and br Office Pavilion, tl, cl, tc Chronicle
Books; P.81 tl and tr, bl LOWERCASE Inc, br Noah Scalin, ALRdesign; P.85 tl João Machado, tr Yee Design, br The
Riordon Design Group Inc; P.86 t and cl Chronicle Books, cr The Riordon Design Group Inc; bc The McCulley Group;
P.87 t and b Chronicle Books; P.92 tr and br R2 (Ramalho & Rebelo Design); P.93 l R2 (Ramalho & Rebelo Design),
ct Eugenie Dodd Typographics, tr Hornall Anderson, c Becker Design, br Eugenie Dodd Typographics; P.96 Einar
Gylfason;
P.97 bl Einar Gylfason, tr Grundy & Northedge, br Supplied by author; P.100
Gee + Chung Design; P.101 tl LOWERCASE Inc, tc Lippincott, tr, b Eugenie Dodd Typographics; P.104–105 British
Film Institute; P.108–109 Becker Design; P.112
João Machado; P.113 tl, tc, bc, br João Machado, tr Sagmeister Inc; P.117 tl and
tr Hornall Anderson Designworks,c LOWERCASE Inc., bl and br Sagmeister Inc;
P.120 All The Riordon Design Group Inc; P.121 The Riordon Design Group Inc;
P.122 picktondesign ; P.123 t and bl Mirko Ilic Corporation, t and br Flowers & Foliage.
本書所有圖片皆受著作財產權保護。上述提供作品的原作者資料，若有疏忽或偏漏，尚此致以最深的歉意。

國家圖書館出版預行編目資料

設計與編排：圖文編排之基本原理與設計應用 / David
Dabner著；普保羅翻譯 . -- 初版 . --〔臺北縣〕永和市：
視傳文化，2003〔民92〕
面；　公分 .

含索引
譯自：Design and layout : understanding and
using graphics
ISBN 986-7652-00-2 　（精裝）

1.工商美術 － 設計

964　　　　　　　　　　　　　　　　92007706